# REMEMBERING
# CHESTER COUNTY

*Stories*
*from Valley Forge to Coatesville*

SUSANNAH BRODY

Published by The History Press
Charleston, SC 29403
www.historypress.net

Copyright © 2010 by Susannah Brody
All rights reserved

*Cover*: Watercolor painting of Chester County by Ada W. Byrnes, sister of the author and an artist with membership in Maine Women in the Arts, the Charleston Art Guild and the Seabrook Island Art Guild.

First published 2010

Manufactured in the United States

ISBN 978.1.59629.953.5

Library of Congress Cataloging-in-Publication Data

Brody, Susannah Wilson.
Remembering Chester County : stories from Valley Forge to Coatesville / Susannah Brody.
p. cm.
Includes bibliographical references.
ISBN 978-1-59629-953-5
1. Chester County (Pa.)--History--Anecdotes. 2. Chester County (Pa.)--Biography--Anecdotes. I. Title.
F157.C4B76 2010
974.8'13--dc22
2010011608

*Notice*: The information in this book is true and complete to the best of our knowledge. It is offered without guarantee on the part of the author or The History Press. The author and The History Press disclaim all liability in connection with the use of this book.

All rights reserved. No part of this book may be reproduced or transmitted in any form whatsoever without prior written permission from the publisher except in the case of brief quotations embodied in critical articles and reviews.

# Contents

Acknowledgements 7
Introduction 9

**Part I. The American Revolution**
Squire Cheyney's Ride to Brandywine 11
Witness to the Battle of Brandywine 13
Black Patriot Ned Hector 17
The Battle of the Clouds 21
Thomazine Thomas Survives a Raid 24
Remember Paoli! 26
Polly Frazer 30
Judge William Moore 33
Abigail Hartman Rice, Nurse at Yellow Springs 35
The Chester County Witch Trial 37
Treason! 40

**Part II. The Nineteenth Century**
The Reburial of Anthony Wayne 43
Thy Friend Pot 46
Duffy's Cut 48

# Contents

| | |
|---|---|
| Ann Preston | 52 |
| Flight to Freedom | 55 |
| The Battle Axes | 59 |
| Edward Hunter, Mormon Bishop | 63 |
| The Swedish Nightingale Visits Yellow Springs | 65 |
| Kidnapped! | 68 |
| The 1852 Woman's Rights Convention | 73 |
| Will Downing Goes to War | 76 |
| Civil War Nurse Lil Zook | 80 |
| The Great Tornado | 83 |
| The Pickering Valley Train Wreck | 86 |
| Buffalo Bill in Chester County | 90 |

**Part III. The Twentieth Century**

| | |
|---|---|
| The Lynching of Zachariah Walker | 95 |
| The Justice Bell Tours for Suffrage | 99 |
| Tuskegee Airmen in Chester County | 102 |
| Filming *The Blob* at Yellow Springs | 105 |
| Bayard Rustin and the 1963 March for Jobs and Freedom | 108 |
| The Johnston Gang | 111 |
| The Ku Klux Klan Parade | 115 |
| Return to Duffy's Cut | 118 |

| | |
|---|---|
| Bibliography | 123 |
| About the Author | 127 |

# Acknowledgements

Many people helped with the completion of this project. Librarians and archivists who provided guidance and support included Diane Rofini and Pam Powell of the Chester County Historical Society, Sandra Momyer of Historic Yellow Springs, Laurie Rofini of the Chester County Archives and Susan Marshall of the Historical Society of Phoenixville. Thank you to Kim Hall, president of the Chester County Historical Society, for allowing me to share pieces of stories that appeared within the society's biography series. I appreciated the encouragement of friends Ann Mitchell, Connie Happersett and Estelle Cremers, as well as that of fellow storytellers Debra Pieri and Barbara Baumgartner. Thank you to Jack Stapleton and Genny Gallagher for helping with photography. Guidance on individual stories was provided by Sarah Wesley, Alice Hammond, Noah Lewis, Nannie Lambert and Dr. William Watson. A special thank-you to Genny Gallagher for her constant support and positive outlook on life. Thank you to Hannah Cassilly and Ryan Finn of The History Press, who guided me through the process of publication.

Family support is always important, so appreciations go to Drew, Joshua, Jason, Michelle, Scout and Isaiah and a welcome to Lindey. I thank my sister, Ada W. Byrnes, who re-created in watercolor my vision of Chester County. A special thank-you to my husband Ronald Brody, who offers support and encouragement in many ways, including computer and editing skills.

# Introduction

*I gazed at those walls and grounds where I had wandered so often, until the last spot was hidden from view by the famed hills and forests of Chester County.*
—from the diary of Anna Temple, February 26, 1864

People have always been an important part of history. By sharing their stories, they enable us to better understand historical events and relate the past to our present-day lives. Storytelling not only helps to preserve history, but it can also bring history alive. The members of the audience become active participants in remembering. Accurate research of historical events provides a foundation for learning that can be enhanced through personal stories. When stories are shared with an audience, the listeners often share their own stories in return. Historians have documented important events in Chester County, Pennsylvania, and some local citizens have achieved national recognition, but there are also stories preserved through the oral traditions of ordinary individuals whose lives were affected by historical events. Oral tradition refers to the preservation of the culture or history of a community by the spoken word of a storyteller. The stories are passed down by word of mouth from one generation to the next. Because of limited written proof, experts sometimes question the validity of such stories. Yet in many cultures,

oral tradition has been the primary means of preserving and sharing the history of the community.

My interest in local history has always been influenced by storytelling. Oftentimes, a small personal story initiated my desire to learn more. Many years ago, I was inspired by the diary of a young woman who lived her entire life in Chester County. Anna Temple delighted in the people and places surrounding her home and felt that she was fortunate to live in such a magical place. In more than thirty years of researching Chester County history, I have yet to find a story based on family lore that proved to be false. Extensive research has frequently provided further validity to the tales told through oral tradition. The family stories should be embraced; they contribute to the full picture of our local history. Many stories feature ordinary people who experienced historical events that took place in the county, while others document the connection of famous people to the local community. The impact of the American Revolution was greatest when thirty thousand soldiers from the British and Continental armies moved through the county between September 1777 and July 1778. Once the new nation was established, many turned their attention to religion and social reform. The history of the Underground Railroad, temperance movement, woman's rights and the Civil War was highlighted by the personal stories of those who participated. The variety of stories presented in this book reflects the diversity of the population. The collection of stories in *Remembering Chester County* spans more than two hundred years, providing a glimpse into the lives of the people who lived in Chester County, Pennsylvania.

# Part I
# The American Revolution

### SQUIRE CHEYNEY'S RIDE TO BRANDYWINE

Squire Thomas Cheyney usually enjoyed his daily horseback ride through his Chester County farmland. But on this September morning, he was concerned about a dream he'd had the night before. Actually, he was not sure whether it was a dream or a premonition. Thomas had envisioned thousands of redcoats storming down on the Continental army. Unlike the political leanings of most of his Quaker relatives, Squire Cheyney was a Patriot. He supported this rebellion and hoped that the Continental army would eventually win, bringing independence from British rule to the American colonies. Thomas decided to ride over to Osborne's Hill, not far from his farm. From that high ridge, he would be able to see much of the lower Brandywine Valley. There was no sign of soldiers on that day or the next, but the premonition persisted.

In September 1777, General Washington and eleven thousand soldiers of the Continental army were gathering along the Brandywine Creek. The British army, eighteen thousand strong, was marching through southern Chester County, coming north from Maryland, where their ships had landed after sailing up the Chesapeake Bay. The Continental army expected to face British troops soon. Reconnaissance information reported that Lieutenant

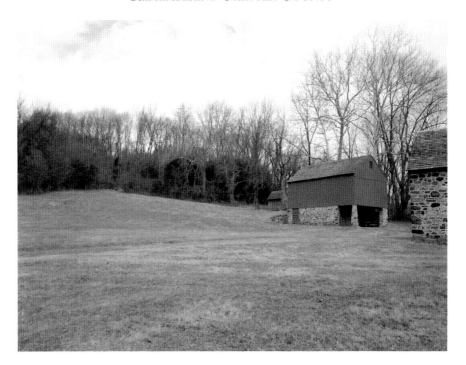

Squire Cheyney rode through these farmlands to reach General Washington's headquarters, both now part of Brandywine Battlefield State Park. *Photograph by Genny Gallagher and Jack Stapleton.*

General Knyphausen's troops were gathering on the west side of the Brandywine. Unknown to General Washington, a large part of the British army, under the command of General Cornwallis, was moving north along the west side of the Brandywine Creek. His aim was to eventually surround the Continental army.

In late morning on September 11, 1777, Squire Thomas Cheyney once again rode to Osborne's Hill. His worst fears from his dream were realized when he saw hundreds of redcoats crossing the creek at Jefferis' Ford. No fife or drum could be heard as the men quietly marched along. The only sound came from the wheels of the artillery wagons as they rolled through the stream and along the dirt path. With all of the talk in the community lately, no one had mentioned the British being in this location. Squire Cheyney wondered whether the Continental army knew of the presence of these British troops. He was determined to provide the information, so he spurred

his horse to a full gallop and headed south. A few British soldiers spotted him and took chase. Fortunately, Thomas had a quick horse, and he knew the roads well, so he easily evaded his pursuers. Still, both he and his horse were quite winded by the time they completed the five-mile run to locate the Continental army.

When he arrived at the headquarters, he tried to explain to the officers why he was there. Some of the staff refused to believe him, thinking he might be a spy or British sympathizer, but Thomas insisted that he be taken to the general. Finally, he was escorted to General Washington and told him about the British movements. General Washington was also doubtful. Chester County was full of Tories, and he did not trust the pacifist Quakers, either. "If you doubt my word," Squire Cheyney said, "put me under guard until you can ask Anthony Wayne or Persie Frazer if I am a man to be believed." Wayne and Frazer were both loyal officers, well trusted by Washington and his staff. The general sent out scouts, who eventually confirmed Squire Cheyney's information.

Once convinced, General Washington quickly changed the positions of his forces, sending the troops up the Brandywine to meet the British. He kept General Wayne's division at Chadds Ford to prevent Knyphausen's men from crossing the creek and joining the rest of the British army. The heaviest fighting took place in late afternoon just north of the Birmingham Friends Meeting. The British army won the Battle of Brandywine. The defeated Continental army was forced to retreat to fight another day. Many believe that if the British had successfully surrounded the Continental army the rebellion would have been crushed. The American Revolution might have ended in defeat on September 11, 1777, if Squire Thomas Cheyney had not warned General Washington.

*Notes: News clippings and manuscripts from the Chester County Historical Society (CCHS); Brody,* Prosperous Beginnings, *27–29.*

## WITNESS TO THE BATTLE OF BRANDYWINE

On the morning of September 11, 1777, fog limited visibility in the Brandywine Valley. A farmer approached a small stone house on the hill

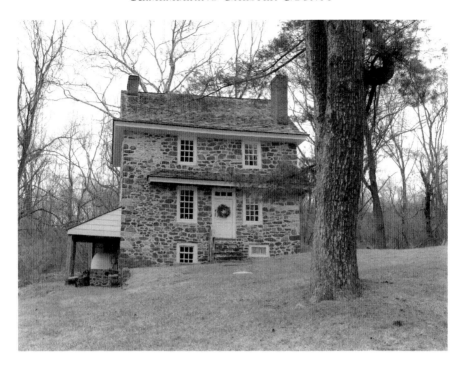

The John Chads House, where Elizabeth stayed during the Battle of Brandywine, is now owned by the Chadds Ford Historical Society. *Photograph by Genny Gallagher and Jack Stapleton.*

looking down on the Brandywine Creek. Widow Elizabeth Chads opened the door for Amos House, her cousin who managed her farm. Knowing that the two armies would soon engage in battle, he urged Elizabeth to accompany him and his family as they moved out of the way, but Elizabeth refused to leave her home. After checking to see that the windows were securely shuttered, Amos hurried away, leaving Elizabeth sitting by the fireplace hearth in a darkened room.

As Elizabeth finished her breakfast, she thought about recent activities in the neighborhood. During the last few days, the Continental army had been gathering nearby. Elizabeth's house was now surrounded by thousands of troops. Most of the troops were on the high fields behind Elizabeth's house, but some remained on the west side of the creek. There had been many times in the past few days when she had worried about being accosted by the soldiers. She was afraid that they might try to steal family heirlooms, like

ns
# The American Revolution

the silver spoons inherited from her mother's side of the family, so she hid her precious spoons in her pocket under her petticoat. When soldiers passed by her house, she retreated to a corner away from the windows. News had spread in recent days that the British ships had landed in Maryland. It would not be long before eighteen thousand British soldiers marched this way.

As the morning passed, quiet seemed to settle around her house. Wondering what was happening, Elizabeth courageously opened the door to take a peek. The warm September sun had baked off the early morning fog, and the sky had cleared enough for Elizabeth to see across the Brandywine. She was startled to catch flashes of the British redcoats in the distance. Of greater concern to her were the Continental soldiers in her yard, only a few feet from her front door. They did not see her, however, because they were looking across the water. Elizabeth quietly closed and bolted the door. Suddenly the sound of a musket firing shattered the silence. Cannons and artillery crashed and thundered. Elizabeth feared that she might be struck right through the stone walls of her home. Afraid of being discovered, she scattered the fireplace coals along the hearth to let the fire go out. Checking to see that her treasured silver spoons were safely hidden in her pocket, Elizabeth moved back to the rocking chair in the corner. She closed her eyes and prayed that her house and her life might be spared.

As the hours passed into the afternoon, Elizabeth tried to shut out the noise of musket and cannon and the shouts and painful cries of the soldiers as they fought in her yard. The Continental troops to the west were forced back across the creek by the British, rejoining those already on the Chads lands. Gunfire slowed down to a scattering of musket shots. Late in the afternoon, the fighting seemed to have stopped in Elizabeth's front yard. She only heard the faint sounds of gunfire far to the north. She wondered if the battle was over and who had won, but she didn't dare venture outside. As evening approached, Elizabeth heard shouting followed by more gunfire near the Brandywine. The fierce sounds of battle were once again close to her door.

She learned several days later that the British under General Cornwallis had moved far to the north, crossing the creek at Jefferis' Ford, seven miles above her home. Their plan was to come from the north and surround Washington and his men. The fiercest fighting had taken place near

Birmingham Friends Meeting, where Elizabeth worshipped. General Anthony Wayne's division of Pennsylvania militia remained on Elizabeth's land to slow the progress of the British on the west side of the Brandywine. The Continental soldiers remained until well after dark before retreating toward Chester to join the rest of General Washington's army. The British had won the battle. Soon the redcoats moved on to the Chads farm. The smoke from the battle slowly faded. The fire in Elizabeth Chads's fireplace went out. No one knows why, but the British did not chase after the Continental army that day or the next. Elizabeth spent four more days alone in her house, while the British army camped outside. The soldiers seemed unaware of her presence in the small stone house, assuming that the owner had fled long before the battle. Fearing discovery, Elizabeth could not restart the fire, get fresh water or go to the outhouse. She huddled in the dark, shivered through the cool nights and prayed that the British army would soon leave.

Early in the morning on September 16, Amos House watched the last of the British troops march out of the area. As soon as he thought it safe, he rushed to see what had become of Cousin Elizabeth. As he approached Elizabeth's home, Amos surveyed all the damage done to the farm on which he worked so hard. Wheat and corn not taken by the army had been trampled beyond use. He saw where wounded soldiers had fallen and been dragged away by their comrades. He passed the hastily built corral in which British soldiers had gathered cows and sheep for slaughter to provide food for their next campaign. He saw that a cannonball had damaged the stone springhouse. All of Elizabeth's chickens and geese were gone. Amos House rushed up the steps to his cousin's house and knocked on the door. For a few very long seconds, he heard nothing. Just when he considered how he might break into the house, he heard a sound. The door opened a crack, and then wider, as the old woman recognized her young cousin. Amos hurried inside and quickly bolted the door.

*Notes: News clippings and genealogical data from CCHS and the Chadds Ford Historical Society; Brody,* Prosperous Beginnings, *37–39.*

# The American Revolution

## BLACK PATRIOT NED HECTOR

In the eighteenth century, there were free blacks living and working in southeastern Pennsylvania. Many joined the army during the American Revolution, but little is known about them. The contributions made by blacks were often ignored in the written history of that time, but the Continental army was the most integrated American army until 1948. Born in 1744, Edward "Ned" Hector was a black teamster who served in the Continental army. Private Hector also served as an artillerist. Ned first appeared on the muster rolls on March 10, 1777. He was assigned to Colonel Proctor's Regiment of the Third Pennsylvania Artillery Company. On September 9, 1777, the regiment reported to Brandywine, Pennsylvania, for the defense of Philadelphia, under the command of General George Washington.

A teamster was a wagon driver dealing with teams of animals. Both the wagon and the horses were his responsibility whether he himself owned the team of horses or worked for someone else. Early in the war, the army had difficulty finding teamsters. Soldiers who were untrained in the job were sometimes assigned as teamsters. They were often unhappy with the work and had no idea how to properly care for horses within a movable army, so the horses suffered. In 1777, the army sought to recruit civilians with teamster experience. Ned was probably trained and employed as a teamster before the war. He was thirty-three years old at the Battle of Brandywine. The army made a request to Congress for one hundred baggage teamsters and ten artillery teamsters.

Ned could have joined the army in several ways. It is not known whether he volunteered or was coerced. When needed, the army sometimes took horses and wagons from their owners. Sometimes men were pressed (or forced) into service. Sometimes owners of the wagon and teams joined the army rather than completely lose their teams. Ned owned his own wagon and team of four horses. Since he was on the muster rolls and later applied for a pension, it is likely that he decided to enlist. Once he joined the army, it was Ned's job to care for the horses and deliver the ammunition and artillery supplies for the company. The artillery wagon carried gunpowder, cannonballs and whatever was needed to operate the cannons. Ned had to keep the ammunition boxes well supplied. He also

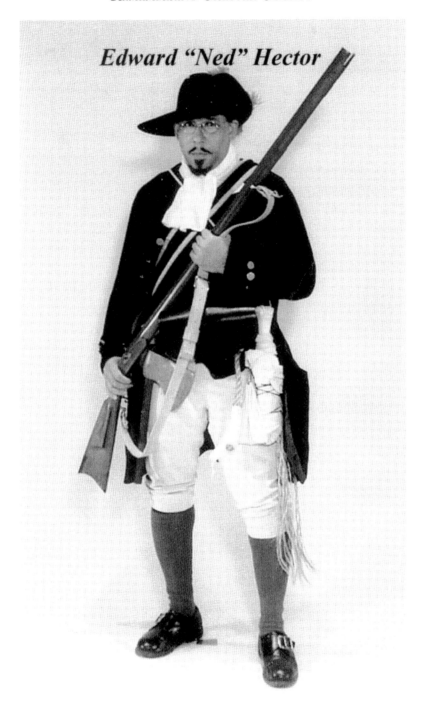

Noah Lewis portrays black Patriot Edward "Ned" Hector in school programs and reenactments. *Noah Lewis.*

loaded the charges, which were the cloth bags of gunpowder that went into the barrels of the cannons.

A team of up to fifteen soldiers was assigned to each cannon. Everyone was needed to protect and move the cannon into position. A cannon could be loaded and fired by as few as three men, but there were usually seven. There were two soldiers called matrosses in front of the wheels of the cannon. Those to the rear of the wheels and tending the powder box were called bombardiers.

The team worked in choreographed action to prepare and fire the cannon. The matross to the right front of the cannon would make sure that the cannon was clear. The matross to the left front of the cannon would insert a wet cloth on a stick into the barrel, while the soldier to the rear left held his thumb over the touch hole. When the left matross pulled the sponge out, a vacuum was created. (To make sure that everything was clear, this procedure could be repeated.) The powder monkey ran back to get the charge from the powder box tender and deliver it to the right matross, who would put it into the barrel of the cannon. The left matross would push it down into the barrel of the cannon using a ramrod. Then the powder monkey would deliver the cannonball, which was put in the barrel and rammed snug against the charge. The left rear bombardier would use a long spike to pierce the gunpowder bag through the touch hole at the top of the cannon. Then he would add some gunpowder to the touch hole. The right rear bombardier, holding a slow-burning rope attached to a pole, awaited the command to fire while the soldiers closest to the cannon stepped away. At the command, he would connect the burning rope to the gunpowder in the touch hole. It would ignite the charge and fire the cannonball! The cannon was then immediately cleaned and readied to load and fire again. Through teamwork these actions could be done in fifteen seconds or less. Besides being a teamster, Private Ned Hector was also trained as a bombardier artillerist. That meant that Ned functioned as a left or right bombardier or tended the powder box. Being in the artillery, Ned was part of an elite battle unit.

On September 11, 1777, Colonel Proctor's artillery company was positioned on the ridge behind the John Chads House, facing the British troops on the west side of the Brandywine. Half of the British army had moved to the north, performing a flanking maneuver and engaging the

Continental army in an area north of Chadds Ford, near the Birmingham Quaker meetinghouse. The British defeated the Patriots, sending General Washington's army into retreat. Late in the afternoon, the rest of the British and Hessian troops crossed the creek and began to overrun the Continental positions. For Proctor's artillery troops on the east side of the Brandywine, the order was given to retreat and to abandon the cannons, guns, wagons and horses. Private Ned Hector went against those orders, refusing to leave his beloved team of horses. He was quoted as saying, "They shall not have my team! I will save my horses or perish myself." Ned guided the team and picked up abandoned muskets as his wagon moved through the field. He successfully escaped with his horses and wagon. Later, his commanding officers chose to ignore the fact that Ned had disobeyed orders, recognizing his courage in salvaging the wagon, team and the only weaponry saved by that company in its retreat. Those arms would be put to good use in other battles, like the Battle of Germantown on October 4, 1777.

Little is known of Private Ned Hector's life after the Revolution. He got married after the war, and he and his wife Jude had four children: Charles, Aaron, Sarah and Isaac. Ned lived in Montgomery County, Pennsylvania. (Originally part of Philadelphia County, Montgomery became its own county in 1784.) He probably continued to work as a teamster. Ned applied three times for a pension. Pensions, ranging from $80 to $120 per year, were granted by the United States government. A pension would have been very helpful to Ned and Jude in their old age. Unfortunately, like many other veterans of the American Revolution, he never received a military pension. In 1833, the Pennsylvania legislature awarded him a single monetary gratuity of $40, the same amount granted to men who had served as little as two months. Apparently, no one in the government cared that Ned had served bravely in an elite fighting unit. Ned Hector died in 1834 at the age of ninety. Jude died a few days later. In 1850, the newly incorporated borough of Conshohocken named several streets after local men of prestige, wealth and fame. One of the streets was named Hector Street to honor a long-unrecognized black Patriot, Edward "Ned" Hector, hero of the Battle of Brandywine.

# The American Revolution

*Notes: Information on the life of Ned Hector was provided by Noah Lewis, who portrays Hector in programs for schools and historic sites. His website is www.nedhector.com. Additional information is available at www.ushistory.org/people/ned-hector.htm.*

## THE BATTLE OF THE CLOUDS

After the Continental army was defeated at the Battle of Brandywine on September 11, 1777, the British army camped in southern Chester County for a few days, while the Continental army traveled through Chester to Philadelphia and up along the east side of the river to the Falls of the Schuylkill. On September 15, General Washington led his troops across the Schuylkill, marching about ten miles west on the road to Lancaster. Washington stopped for the night, setting up headquarters at the home of Randall Malin at the intersection of Lancaster and Swedesford Roads. The army moved a short distance farther west along the Lancaster Road. Early in the morning of September 16, Washington learned that the British army was heading in their direction. He ordered his troops to battle formation along the South Valley Hill. It took quite a while for the men to get into position along the road west of Paoli on the south ridge (near where Immaculata College is now located).

Meanwhile, the British army was divided. General Howe's men were still camped near Dilworthtown. Some of the Hessians had been sent to Wilmington, Delaware. General Cornwallis had taken some of the British battalions toward Chester. Information about Washington's movements reached the British camps in the afternoon of September 15. General Cornwallis's troops were ordered to move north, but they did not start their march until well after midnight. Traveling in the dark with light rain and wind made progress slow and difficult. General Howe's troops began their ten-mile march at about 5:00 a.m. on September 16. The British army merged at the village of Goshen and formed lines along the south ridge a short distance north of the Goshen meetinghouse (near Hershey's mill).

Early in the day, the sky was a steel gray with some scattered showers. As the afternoon progressed, the scattered showers turned into a steadier downpour. The two armies were about a mile apart, facing each other on

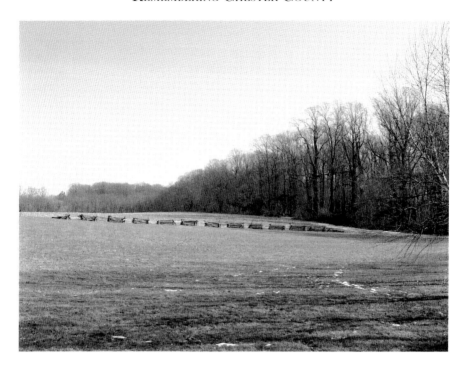

The Battle of the Clouds took place near these Chester County fields. *Photograph by Genny Gallagher and Jack Stapleton.*

the two slopes of the south ridge. Under the command of General Anthony Wayne, the advance forces of the Continental army planned to skirmish with the enemy's front lines, hoping to slow their progress. At 2:00 p.m. there was some skirmishing to the east near the Three Tuns Tavern and along the west lines not far from the Boot Inn. Once the fighting began, the east guard retreated almost immediately under assault from the British advance troops. Along the western front, the Continental troops performed better and nearly captured some Hessians who had accidentally gotten separated from the rest of the British troops. Overall, the British fared much better. Most of the casualties—killed, wounded and captured—were Continental soldiers.

When the skirmishing began, the bulk of the Continental army was still in the process of forming battle lines. Although soldiers were organizing on high ground, General Washington was concerned about their movements once the battle was over, because there were fewer roads for exiting the area than those existing closer to White Horse Tavern about two miles to the north. With the

increasing rains, he also worried about how the fighting would proceed if the rains continued. If the battle came down to bayonets, the British were much better skilled and supplied. Before the full battle began, General Washington made the decision to move his troops back toward the North Valley Hills.

General Wayne's advance troops were still fighting with the British late in the afternoon when the rest of the Continental army began to reposition itself north of the White Horse Tavern. The repositioning of the Continental army proved to be a wise decision for General Washington. At about 5:00 p.m. the storm changed from a steady light rain to a torrential downpour, described by a British soldier as "an extraordinary thunderstorm…the heaviest downpour in this world." The storm continued at this extreme level throughout the night and into the next day. Muskets were rendered useless, and gunpowder was soaked beyond use. Within minutes of the start of the deluge, both armies had been stopped in place. They could not see, they could not shoot and they could not easily move; some soldiers were already stuck nearly knee deep in the mud.

The battle had barely begun when it ended. The British decided to establish camp right where they were, but they had left behind their tents, so they took over many of the area's farm outbuildings. General Washington decided to move his troops north toward their military supplies in the iron-making region of northern Chester County. They marched up the North Valley Hill six miles toward Yellow Springs. Years later, a young soldier, Jacob Nagle, described that march. Streams were flooded, and the mud was so deep that the soldiers had to push the wagons and horses up the hill. They marched through the rain and mud for the eight hours that it took the army to get to Yellow Springs. A few days later, Washington reported to Congress that the ammunition had been destroyed and that the army in this condition could not make a stand against the enemy.

What might have been a battle on the size and scope of the Battle of Brandywine became instead a footnote on the army's Pennsylvania campaign. It was not long after this encounter between the two armies that the event was described as "the Battle of the Clouds," an accurate description since it was the storm clouds that ultimately won the battle. Today, there is a township park near the old White Horse Tavern in East Whiteland that is called Battle of the Clouds Park in honor of this now famous event.

*Notes: McGuire*, Battle of Paoli, *28–37; Futhey*, 100th Anniversary of the Paoli Massacre*; Pleasants, "Battle of the Clouds"; East Whiteland Historical Commission pamphlet, "Battle of the Clouds."*

## Thomazine Thomas Survives a Raid

It was a cool, clear late September evening. The last skirmish with the rebels had been halted due to the severe storms that destroyed ammunition. Much of the British army was camped in the fields where the battle was to have taken place. Unlike the heavy rains of previous days, the air was calm as the British scouting party moved quietly along the farm lane. The three redcoats looking for supplies had been informed by a Tory sympathizer at the Warren Tavern that there was a mill on the property of Colonel Richard Thomas in West Whiteland Township. Although a Quaker, Richard Thomas had joined the army.

The scouts expected the raid to proceed without a flaw because the farm's owner was an officer with Washington's troops, and so he would not be at home to defend his property. The British soldiers found the mill and the barn without difficulty, but there was not much left to take. Either the farm had already been raided or the family had given most of their stock and crops to the Continental army. They found a small wagon or cart and filled it with the few supplies remaining—some tools. Then one of the soldiers noticed a woman near the back door of the farmhouse. Hoping to get more, one of the men suggested interrogating her.

Thomazine Thomas had heard unusual sounds outside and had started walking toward the mill to investigate. She soon saw the soldiers and quickly turned back toward the house, hoping to get inside and bar the door. The men caught up to her, forced their way inside and demanded more supplies. Mrs. Thomas told them that there was nothing left but what they were already stealing. Raiding parties had been coming to the mill for days. Knowing that people often hid their personal treasures, one soldier asked about the family valuables—silver, china, watches and more—anything that could be traded or sold. When Mrs. Thomas refused to tell them anything, the soldiers resorted to a physical threat. They lifted her stout body and

# The American Revolution

The Thomas Mill, object of a British raid, has stood in West Whiteland for nearly three centuries. *Photograph by Susannah Brody. Courtesy of the Uwchlan Township Historical Commission.*

attempted to hang her by her kerchief on one of the pegs in the kitchen wall. The wooden peg gave way under her considerable weight, and Thomazine fell to the floor.

The soldiers repeated the threat, but Mrs. Thomas refused to cooperate. She was once again lifted by the men and hanged on another peg. That peg also broke, falling to the floor with Mrs. Thomas. By this time, one of the soldiers warned that they were spending too much time in one place. He reminded his comrades of the severe penalty for attacking civilians. Earlier in September, two soldiers had been hanged for looting. They also did not want to be captured by a rebel raiding party, so they gathered what they could and moved out into the night, leaving Mrs. Thomas in a heap on the floor with a terrible look of fear on her face. However, she was not looking at the departing soldiers; she was looking up at the wall where the wooden pegs had been. Thomazine knew that the next peg in the row was not wooden—it was part of the iron bar that anchored the peg board deep into the stone wall of the kitchen. If the soldiers had tried just once more, she would have been hanged.

*Notes: This story is part of the oral history of the Thomas and Downing families, whose descendants still live in Chester County. It was written down many years ago by Downing descendant and reporter Ned Pyle; Brody,* Prosperous Beginnings, *40–41; McGuire,* Battle of Paoli, *26.*

# Remember Paoli!

After the Battle of the Clouds, the British army camped in the Great Valley. The Continental army moved through Yellow Springs and up into the iron country in northern Chester County to resupply ammunition. General Washington ordered General Anthony Wayne to take a company of men to the rear of the British army to harass the redcoats and keep track of their location.

General Wayne was an excellent choice for this assignment. He lived a few miles from where the British were encamped and was very familiar with the countryside. He was a natural leader and had already demonstrated exceptional military skills. With 1,500 soldiers from his own company and others specifically chosen for the assignment, General Wayne kept tabs on the activities of the British. They followed the rear of the British army, keeping track of its supply and artillery wagons. They moved around, changing positions and camps to avoid discovery. On Saturday, September 20, the British soldiers under General Howe were camped east of Paoli, between the Lancaster and Swedesford Roads. Cornwallis's men were closer to Valley Forge near the Schuylkill River, which was still raging from the recent storms. Wayne's Continental troops were camped in the great valley between the Paoli and the Warren Taverns (in an area that is now the borough of Malvern).

General Wayne was waiting for the Maryland militia under the command of General Smallwood. The Maryland troops were expected to increase General Wayne's capabilities in harassing the enemy. They had been expected all day. This may be the reason that Wayne's company did not change the location of the campsite, even after a scout reported that the British were planning to attack that night. Meanwhile, General Washington crossed the Schuylkill at Parker's Ford and headed down along the east

# The American Revolution

The Paoli Massacre has been venerated in Malvern with the Paoli Memorial. *Photograph by Genny Gallagher and Jack Stapleton.*

side of the Schuylkill toward Philadelphia. There was a possibility that the smaller Continental army could surround the British, but this repositioning of the army also left General Wayne's company more isolated.

Late Saturday afternoon, Wayne and his commanding officers dined with John Bartholomew, a local resident well known to Wayne. Bartholomew expressed grave concerns that the British were planning to attack that night or the next morning. For several days, General Wayne had thought that the British were unaware of their presence to the army's rear, but Bartholomew's information made Wayne and his officers realize that the British knew their location and were planning to retaliate. If Wayne was going to move the camp again, it would have to be soon. Perhaps he thought that nothing would happen until morning, or perhaps he was still waiting for the arrival of the Maryland militia. As storm clouds approached, instead of ordering the troop to break camp and move, General Wayne ordered that "booths" be built. Booths were small tentlike structures made of saplings or cornstalks

that were used to protect the arms and ammunition from rain. After the heavy rains on September 16 destroyed the ammunition, it is not surprising that Wayne felt the need to be cautious. He also set up extra pickets with close to twenty men each to protect the camp, warn of approaching forces and, if necessary, slow down an enemy attack.

The British were well aware of the Continentals who had been following them for days. They knew that the company was under the command of General Wayne and that he was one of General Washington's best military men. They had planned a nighttime attack earlier but were thwarted when Wayne suddenly moved his encampment. At about ten o'clock on the night of Saturday, September 20, Major General Charles Grey led a force of British troops to attack Wayne's company. The British soldiers made up of light infantry, dragoons and Royal highlanders were those trained in special forces–style abilities—rangers skilled with rifles and bayonets. Grey ordered that the muskets not be loaded. He planned a surprise attack in which the enemy could not locate them by the sound or flash of their guns.

About 1,200 British soldiers marched silently along Lancaster Road, taking civilians prisoner as they moved past private homes. Grey did not want anyone running to warn General Wayne. The British had help from Loyalists in locating the pickets surrounding the camp. As the pickets noticed approaching men, they called out for identification and got no response from the British. The infantrymen surrounded the pickets and attacked with their bayonets, killing and wounding in the silence of the night. Some of Wayne's scouts were able to escape and rush toward the camp to offer warning. The British continued their silent march. Just as Grey's assistant, John André, had predicted, the Continentals began shooting into the dark. Not only did the gunfire expose their positions, but in many cases soldiers were shot by friendly fire, killed and wounded by their own troops.

Near midnight, General Wayne rode along the lines rousing the troops. The men turned out in less than five minutes, but no one could have imagined what was about to happen. A light rain had begun to fall, so the men took the time to put their cartridge bags under their coats. The order was given to evacuate the camp. The supply and artillery wagons began to move out toward the west.

General Grey ordered his men to dash. In silence, the British soldiers rushed through the woods and into the camp. They could see outlines of the

# The American Revolution

Continental soldiers lit by the campfires and the exchange of gunfire, but the gunfire was all from the Patriots; the British guns remained silent. Against bayonets in the dark at close range, the riflemen and musketeers did not stand a chance. The second wave of British dragoons shouted "Huzzah!" as they rushed forward, swords and sabers in hand. There was great confusion among Wayne's troops. Darkness and surprise caused many to panic and run. One soldier thought that he was alone when he hid in a nearby swamp, only to discover in the morning that more than fifty of his comrades had done the same thing.

The retreat was held up by a fieldpiece that had lost its wheels, causing the artillery wagons and the marching regiments to pause while it was cleared. Then the British attacked the rear of the retreating troops. It was nearly impossible for the men to form a line of defense. Continental soldiers attempted to take cover in the woods away from the light of the fires, but the British were not finished. The final charge was made by the Black Watch, two battalions of Royal highlanders known as the fiercest of fighters. They came in screeching war yells, with bayonets and swords in front. They kept their ranks closed as they swept across the field in a solid front, killing and wounding and stepping over bodies—showing no mercy.

For the Continental soldiers, the battle was a disaster. Few prisoners were taken, and witnesses later reported men being repeatedly stabbed even after they were down. One British officer reported taking seventy-one prisoners, most of them severely wounded. For the British, the battle that lasted less than an hour was a resounding success. In the long run, the massacre inspired many Continental soldiers to retaliate in all subsequent encounters. Years later, the reputations of Generals Grey and Howe reflected the negative effects of Paoli. "Remember Paoli!" was an often-heard shout in battles.

On October 13–14, 1777, there was an official inquiry into General Wayne's conduct at Paoli. Sixteen officers testified. The decision was unanimous—acquitting Anthony Wayne and stating that he did everything that could have been expected from an active, brave and vigilant officer.

*Notes: McGuire,* Battle of Paoli, *38–47; Hickman,* 100th Anniversary of the Paoli Massacre; *news clippings from CCHS.*

## Polly Frazer

In 1766, the beautiful Mary "Polly" Worrall Taylor of a prominent Quaker family married the handsome, wealthy Scotch-Irish Presbyterian Persifor Frazer. Despite family opposition to their marriage, Persie and Polly were described by friends as a beautiful couple: attractive, well educated and devoted to each other. They were both staunch Patriots, willing to do whatever was needed to help the colonies gain independence from British rule.

Persie Frazer joined the Pennsylvania Militia in January 1776. The military campaign in the fall of 1777 had an enormous impact on the Frazer family. Their home in Thornbury was within a few miles of the Brandywine battlefield. Military supplies had been stored at their estate before the battle. After the September 11 battle, British soldiers invaded the township, looking for Captain Frazer, looting the farm—carrying off food, clothing, supplies—and destroying much of what could not be removed. The British commander was so impressed with Polly Frazer's strength during this encounter that he ordered his men not to burn down the house and barn. On September 15, Persie Frazer was captured at the Blue Ball Tavern near Chester. He was eventually taken to prison in Philadelphia, where he was held under poor conditions until his successful escape on March 17, 1778.

Neglect, bad food and sickness increased the suffering of colonial prisoners during the winter that the British controlled Philadelphia. Polly (who was pregnant) visited her husband seven times during his six-month stay in prison, bringing food and clothing for the prisoners. Flour, eggs, chickens, butter, cheese and fruit were packed in saddlebags. The British usually welcomed the provisions brought by relatives and friends of the prisoners because it meant that they did not have to feed the prisoners from their own stores. Still, there was no guarantee that the food Polly brought would actually go to Persie. Each visit involved a horseback ride of several hours in winter weather, traveling through areas controlled by both armies and crossing the Schuylkill River by ferry or floating bridge. Her journey was made possible because she had a travel pass signed by General Washington. She was sometimes accompanied by her neighbor, Marjory Hannum Gibbons, sister of John Hannum, who was captured at the same time as Persie. One time Polly took her nine-year-old daughter, Sally, with her.

# The American Revolution

One journey stands out as both the most important and the most dangerous. Polly was traveling with Marjory Gibbons. The two women rode horseback along Chester Road and then on toward Philadelphia and crossed the river at Gray's Ferry, a famous floating bridge that was one of the most important crossings into the city. The journey was exhausting for Polly. They arrived after dark and stayed with Mrs. Jenkins, a friend who helped them to gain admittance to the prison.

On this particular visit, Persie looked unwell. He showed Polly part of his bread ration, which contained small worms. He asked his wife to perform a dangerous mission. He wanted Polly to take some of the bread and a note to General Washington. The note, signed by several prisoners, described the terrible conditions in the prison. Polly took the bread and note. That night, she sewed them inside the hem of her petticoat. The next morning, the two women departed from Philadelphia to return home to Chester County. They were stopped at the ferry crossing and taken inside the guardhouse to be searched. The two women doing the search struggled with Marjory Gibbons to search her clothing, even removing her shoes and stockings and unbraiding her hair. Mrs. Gibbons created quite a fuss during the search, screaming and flailing her arms with each touch.

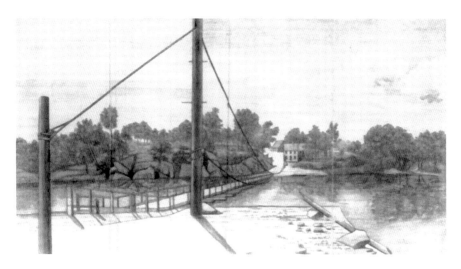

To visit her imprisoned husband in Philadelphia, Polly Frazer had to cross the "Floating Bridge" at Gray's Ferry. *Library of Congress Prints and Photographs Collection.*

Polly stood quietly waiting her turn, trying to remain calm and not show her fear of the enemy finding the note and bread hidden in her petticoat. She thought of her children at home. With Persie in prison, the responsibilities of running the house, farm and ironworks fell solely on her shoulders. She worried about what would happen to the prisoners if she were caught. Their conditions would surely worsen. Tired from the difficult search of Mrs. Gibbons, the women turned to Polly, noticed that she was pregnant and apparently assumed that she was harmless. After a cursory search of her outer clothing, the women searched the nearly empty saddlebags and allowed them to continue on their way.

Polly was relieved once they crossed the river and rode through Chester County, arriving home in the middle of the afternoon. Normally, Polly would have gone to bed to rest from the difficult journey, but on this day she changed her clothes, ate a slight meal and had her saddle put on a fresh horse. It was raining when she began the second ride—this time going to General Washington's headquarters in Whitemarsh. It was already dark when Polly arrived at the Swedes' Ford to cross the Schuylkill River. Afraid to cross the river by herself, Polly entered the nearby tavern, which was full of Continental soldiers drinking and carousing. She found the commander and asked for assistance in crossing the river. The commander saddled his own horse and escorted Polly through the rising water and strong currents. They arrived at the encampment late at night, so the officer found accommodations for her. The next morning, Polly was taken to General Washington. She gave him the note along with the bread. Soon, the general communicated with the British general Howe regarding the treatment of American prisoners, and their conditions improved somewhat. The general sent an officer along with Polly to see that she returned home safely.

Persie managed to escape prison in March 1778 and return to his regiment, but there is a sad footnote to Polly's story. After a difficult delivery, Polly gave birth in early May to a girl, but the baby, Martha, was never healthy and died before turning two months old. Polly and Persie often wondered how that difficult winter might have affected the baby's chance of survival.

*Notes: News clippings from CCHS; Slaymaker, "Mrs. Frazer's Philadelphia Campaign," 185–209.*

# The American Revolution

## Judge William Moore

Not all of the residents of southeastern Pennsylvania were Patriots. The population was split in thirds: one third Tories, loyal to the British Crown; one third Whigs, staunch Patriots; and one third Quakers, who were opposed to war regardless of their allegiance. William Moore was a Loyalist, or Tory, who lived in a mansion looking down on the Schuylkill River near what is now Phoenixville. He had been a judge for more than forty years and was accustomed to being treated with respect, at least before the war. His first major confrontation with local Patriots came in 1775, long before the Declaration of Independence. A group known as the Committee of Chester County was chaired by Anthony Wayne, son of William's longtime political adversary, Isaac Wayne. The committee sought to force Tories to recant their allegiance to the Crown.

At that time, a political eavesdropper, Jacob Smith, had reported to the committee a conversation he had heard. Smith claimed that in May 1775, Judge Moore had called the people of Boston "a vile set of Rebels." Members of the committee paid him a call and wanted him to sign their statement of allegiance. He felt quite comfortable with his allegiance to the British Crown, but to get rid of them, Judge Moore offered to sign, adding a cleverly worded but caustic note: "I also further declare that I have of late encouraged and will continue to encourage learning the military art, apprehending the time is not far distant when there may be occasion for it." His signature on their note, along with this statement, was accepted as a satisfactory resolution. Had Anthony Wayne been there, he would have recognized the sarcasm in Moore's statement.

In the fall of 1777, the colonies were at war with England, and the two armies were maneuvering through Chester County. William had enjoyed playing host to several officers of the British army when they had passed through the countryside near Phoenixville. He was sorry to see them move on to Philadelphia without leaving at least a regiment to protect Chester County's Loyalists such as himself. He had successfully avoided confrontation with the rebellious rabble in the community, but it appeared that he would not easily escape the army's looting. The British army settled in for a comfortable winter in Philadelphia, while the Continental army established an encampment at Valley Forge.

Moore Hall was the residence of Loyalist judge William Moore. *Khali Hihi of the Schuylkill Township Historical Commission.*

Isaac Anderson was put in charge of Continental troops who were sent to the homes of British sympathizers to gather supplies. A handful of armed men appeared at Moore Hall to confiscate arms owned by the well-known Tory. Seventy-eight years old and in poor health, William could do nothing to prevent the invasion of his home. An angry William Moore sat by the window while soldiers searched his Phoenixville home. Plagued with old age and a painful episode of gout, he was confined to an easy chair in the front room. He hoped that they would soon depart before he actually expressed what he thought of them. How dare they enter his house and search his belongings? Wasn't a man's home his sacred castle? The soldiers gathered the weapons—just a few guns and some knives. Then one soldier descended the stairs with the prize of the day, a beautifully wrought sword whose handle was inlaid with gold and silver plate, clearly an ancient family heirloom. The judge calmly asked to see the sword once more before it was carried off. No sooner had the sword been handed to him than he used his good foot to snap

the blade from the handle. With a gleam in his eyes, he returned the now useless blade to the startled soldier, crying out, "There, take that if you are anxious to fight; but you have no business to steal my plate!"

William Moore thought that this incident with the weapons would be the last of his contact with the rebels. Soon, though, he had to suffer through more indignities when a Committee of Congress resided at his home for two months early in 1778 while it reviewed camp conditions, and officers of the Continental army were quartered at Moore Hall throughout the Valley Forge encampment. William Moore was eighty-four years old when he died in 1783, still a confirmed Loyalist.

*Notes: News clippings and miscellaneous data from CCHS and the Schuylkill Township Historical Commission.*

## Abigail Hartman Rice, Nurse at Yellow Springs

Abigail Hartman Rice had a remarkable but short life in Chester County. Born in Germany, she was nine years old when she came to Pennsylvania with her parents in 1751. At the age of fifteen, she married Zachariah Rice. In thirty-two years of marriage, they had twenty-one children, considerable even in the age of large families. Most of their children lived to maturity. Her contributions to American independence are noteworthy.

There is a story about Abigail Rice and George Washington that has been preserved in family and neighborhood lore for more than 230 years. After the Battle of the Clouds, General Washington led his soggy troops to Yellow Springs. The next day, the army continued its march to the iron region to resupply ammunition. Tradition says that the troops stopped at the springhouse of the Rice farm near Yellow Springs. Abigail Rice offered water to the soldiers. She handed a very finely crafted ladle to the general, calling him "My Lord." General Washington returned the ladle with thanks, admonishing her for her deference and saying, "We have no titles here; we are all brothers." The beautiful handcrafted ladle became a prized family heirloom, passed on from one generation to the next until recently, when the Chester County Historical Society acquired it from a Rice descendant.

Abigail and Zachariah Rice raised their large family in this farmhouse near Yellow Springs. *Photograph by Genny Gallagher.*

Abigail Rice served as a nurse at the Army Hospital built near her home in Yellow Springs. In the eighteenth century, nursing was a difficult and often thankless job with serious risks of exposure to infectious disease. Nurse duties included bathing and grooming patients, emptying chamber pots and cleaning hospital rooms. Bed linens were changed by nurses but only upon orders from surgeons. Sometimes the nurses cooked for patients. Abigail may have been asked to help care for injured soldiers by Dr. Samuel Kennedy, who owned the Yellow Springs plantation. He offered the health spa to the military for use as a hospital. After the Battle of Brandywine, the army needed more medical facilities. Dr. Kennedy was reassigned from a temporary hospital at Lititz, Pennsylvania, to Yellow Springs in December 1777 as the Continental army settled into its winter encampment at Valley Forge, ten miles to the east. Construction of the new hospital building was begun in January 1778 and completed in May. A carpenter, Zachariah Rice, was one of the primary builders.

While the hospital was under construction, Dr. Kennedy set up care centers in the three barns at Yellow Springs and sought nursing help from the neighborhood. Abigail Rice and Christina Hench volunteered despite both having considerable family responsibilities. A dozen of Abigail's children (ranging in age from three to twenty) were at home. Each day, Abigail arose before dawn to take care of her household before going to Yellow Springs about a mile and a half away. As soon as she arrived, she emptied and cleaned the chamber pots. She changed patients' dressings as needed, made

sure that they had food and fed those who needed assistance. Then she swept the floor, sprinkling it with vinegar, an early technique in sanitation. She usually did not return home before evening and was at times asked to return for emergencies during the night.

Yellow Springs (and its auxiliary buildings, such as Zion Church and Uwchlan Meeting) housed the most serious medical patients. Mildly sick and slightly wounded soldiers received treatment at regiment "flying" hospitals at the Valley Forge encampment. Abigail was responsible for the care of the soldiers who were the most seriously ill. There were some soldiers at Yellow Springs being treated for battle injuries, but most of the more than 1,300 patients treated in the first six months were suffering from infectious diseases, including dysentery, typhus and typhoid fever. Smallpox existed but was not prevalent at Yellow Springs because of General Washington's order that his army be inoculated. That dreaded disease had already ravaged the army in the early years of the war.

For all their work, nurses were paid about two dollars per month, if they were actually paid at all. No records have survived to show how Yellow Springs nurses like Abigail were compensated for their efforts to care for and improve the conditions of the soldiers. Abigail and Christina were indirectly acknowledged for their work. Spring inspections reported that the Yellow Springs facilities were "very neat and the sick comfortably provided for" and "neatly arranged, clean and healthy." Dr. Kennedy and his staff constantly faced shortages of items like soap, sheets, candles, shirts and writing paper. Many of these items were likely supplied by Abigail and other local women.

Abigail died early, at the age of forty-seven. Although Abigail did not die until 1789, several years after the war, her death was said to be caused by the chronic side effects of the typhus she caught while caring for the sick at Yellow Springs.

*Notes: News clippings and genealogical data from the Archives of Historic Yellow Springs (HYS).*

## THE CHESTER COUNTY WITCH TRIAL

By 1780, the Revolutionary War had put a strain on the residents of Chester County. Although the battles had long since moved south, men serving as

soldiers were gone for long periods of time, leaving the women to run both farm and household. Many struggled to survive and hold on to their lands. Emotions ran high among some superstitious women of the community. Molly Otley was the defendant in Chester County's only witch trial. In the eighteenth century, witchcraft was considered a serious offense, to be tried only in the highest court, so this so-called trial had no real legal basis. It was mob action, but that did not stop the crowd from pursuing its own solution.

Molly Otley was an elderly widow who lived alone in a small cottage on lands in Goshen known as the "Barrens." The Barrens contained an outcropping of rare green stone, called serpentine, that made growing crops difficult. Molly was pleasant, intelligent and friendly. One day in 1780, her neighbor, Joshua Ashbridge's daughter, became demented and began uttering strange sounds, some of which were heard to sound like she was saying, "Molotly, molotly, Moll Otley." Superstitious neighbors, hearing the girl's cries, decided that Molly Otley was a witch who had put a curse on the poor child. To anyone thinking clearly, it seemed unlikely that a witch would cause her victim to call out the witch's own name, but the theory spread quickly through the community. Many wanted to arrest Molly and bring her to a "Peoples" trial to be held at the Turks Head Inn, at the major crossroads that became the town of West Chester.

James Gibbons was a wealthy farmer and prominent citizen who owned the six-hundred-acre farm that later became the Westtown Boarding School. He was held in high regard because of his education and his skills in handling delicate legal matters. The accusers asked for his help in "arresting" Molly. Although James thought the witch accusations ridiculous, he agreed to speak to Molly and ask her to attend the gathering at the Turks Head Inn. James drove his carriage to Molly's house, and he was welcomed into her home. When he explained the reason for his visit, Molly expressed shock and disbelief. She could not imagine that anyone could realistically think of her as a witch. James urged her to go with him to meet her accusers and bring the matter to a satisfactory conclusion. Molly agreed and returned with James to the Turks Head Inn. James had underestimated the fervor of the growing crowd.

While they awaited Mr. Gibbons's return, the citizens planned how they would try Molly, using all of the usual beliefs of witch behavior. As a precaution, Molly's image was drawn on a board, and pieces of silver were shot at the image. The women believed that if they hit her image with silver slivers the

# The American Revolution

Molly Otley lived in a small cottage in Goshen Township. *Alexander Lindey etching, 1924. Courtesy of his niece, Susannah Brody.*

wounds would surely be visible on her real body. When Molly arrived at the inn, she inquired about the accusations in a calm and reasonable manner, but no one was interested in responding to her questions. They were so sure that she was guilty that they grabbed her and tied her hands behind her back. Then she was carefully examined by several women. Molly's body showed no sign of injury from the earlier attack on her image. This lack of wounds did not prove her innocence. Instead, the women decided that as a witch Molly must have very strong powers to remain uninjured by the pieces of silver.

Dismayed by the behavior and ashamed of his involvement, James Gibbons protested the manner in which Molly was being treated, but the crowd ignored him and moved on to their next action. They took her to a local mill, at which there was a large commercial balance scale. Molly was put on one side of the scale, and a Bible was placed on the other side—it was thought that a Bible would always outweigh a witch. Molly told them that she would surely weigh more than the Bible, and she was proven correct. The side with the Bible rose, and the side with Molly descended. Still the crowd was not satisfied.

The next suggestion was that they throw her into the millpond, because everyone knew that if she were a witch she would readily swim out but if she were innocent she would sink like a stone. By this time, more rational members of the group had become doubtful. They suspected that some hysteria had been involved in the charges. Mr. Gibbons and others refused to allow Molly to be thrown in the pond.

Then someone suggested a final solution. If the bewitched person (the Ashbridge child) drew blood from the witch's face and the witch prayed for the child, the child would recover. So Molly was taken to the Ashbridge house. Molly appealed to Mr. Ashbridge to bring some sense to the mob, but Mr. Ashbridge did not care about Molly. He would do anything to help his little girl get better. So he gave his daughter a small knife. At this point, Molly had had enough. She said, "Joshua, I will not let thy crazy child cut me. If it must be done, cut me thyself!" The accusers protested that, according to tradition, the victim must be the one to cut the witch; the crowd held Molly down while the girl scratched her face. With blood dripping down her face, Molly cried, "My God, have mercy on this child and restore her to health." Apparently satisfied, the crowd finally dispersed, and Molly Otley was freed to return to her home. Some of the superstitious women remained convinced that Molly was indeed a witch. After all, Molly had prayed for the child after she had been scratched, proving their superstitions to be correct. It is unknown whether the poor child was ever cured of her dementia. Although James Gibbons visited her regularly, Molly Otley became more of a recluse, having no interest in communicating with any of the superstitious people who would treat a neighbor in such a despicable way.

*Notes:* Sunday Bulletin, *"Neighbors Freed Old Woman"; Futhey and Cope,* History of Chester County, *414; news clippings from CCHS.*

## Treason!

Susanna Parker Longenecker lived with her husband, Jacob, in Coventry Township, Chester County, Pennsylvania. They were active members in the Coventry Church of the Brethren and devoted pacifists. Although their

religious convictions prevented them from participating in the war, over the years they indirectly supported the American cause in many ways. At various times, Jacob was called on to contribute forage, quarter, teams or provisions. In the fall of 1777, their farmhouse provided shelter to wounded soldiers when the Continental army crossed the Schuylkill River near Parker Ford. The Longeneckers were known for their kindness toward strangers in need. Their home was located along one of the few public roads in the region. Travelers often sought and received shelter and refreshments. At no time during the struggle for American independence had there been any reason to believe that either Jacob or Susanna was unfriendly to the cause.

In 1782, sixty-eight-year-old Susanna was at home alone with her eight-year-old granddaughter while Jacob was away on a farm errand. Four strangers came to the house and asked for food. Although she did not know the shabbily dressed men, Susanna welcomed them into her home and provided them with food and drink. Before they left, the men asked her for directions to a neighbor's farm. At this time, the men implied that they might be British soldiers, recently escaped from a prison camp in Lancaster. They were seeking help from Susanna's minister, Reverend Martin Urner, who was known to be a Tory. She gave them directions, and the men soon departed. Susanna was glad to see them go. With Jacob out of the neighborhood, she was not comfortable having that many strange men in her home.

A few days later, Susanna Longenecker was arrested and charged with aiding the enemy. Her crime? Giving some victuals and drink to four travelers and directing them farther along the road to the home of a person about whom they inquired. She was taken to the city of Chester, the county seat of Chester County, for prosecution. Quickly convicted, she was adjudged to pay a fine of £150 or, in default of payment, receive 117 lashes on the bare back at a public post.

Jacob and Susanna were devastated by the decree. What had she done wrong? How could they possibly pay the fine? What would happen to her? In February 1783, the court was petitioned by several friends of the Longeneckers. The appeal was presented to the Supreme Executive Council, Pennsylvania's highest court. Susanna pleaded that she was ignorant of any law against giving food to British prisoners, that they did not at first indicate who they were and that, given that there were four men, she might not have

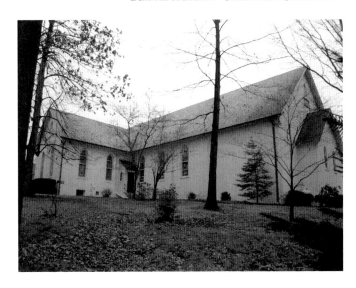

Susanna and Jacob Longenecker worshipped at the Coventry Church of the Brethren. *Photograph by Genny Gallagher and Jack Stapleton.*

had a choice but to do as they said. Surely she should not be burdened with so heavy a sentence. The friends indicated that she was a woman of good character who had always helped those in need. She had done nothing to receive such harsh treatment.

The Supreme Executive Council seemed sympathetic to her plea. Although the conviction stood, the court eventually reduced her fine to fifty pounds. A collection was taken, and Susanna's fine was paid by friends and neighbors. Reverend Urner appealed his similar conviction on the same day, but his plea was denied without comment. Susanna died in 1796 at the age of eighty-two without ever learning that she had not unintentionally given aid to the enemy. The four men who had visited her home were actually soldiers from the Continental army, who disguised themselves as British soldiers and went out into the community to test the loyalties of local citizens. Susanna Longenecker was an unfortunate victim of an intentional entrapment.

*Notes: Cryer,* Longenecker Family Newsletter, *2; Minutes of the Supreme Executive Council, 501–2; genealogical data from CCHS; MacMaster, Horst and Ulle,* Conscience in Crisis, *513–16.*

# Part II
# The Nineteenth Century

### THE REBURIAL OF ANTHONY WAYNE

Much has been written about Anthony Wayne, one of the American Revolution's most famous soldiers. His place in history is well recognized for his military achievements. An interesting footnote to the life of Wayne actually took place several years after his death.

Anthony Wayne resided with his family in a gracious mansion near Paoli. In 1793, President George Washington asked Anthony Wayne to return to government service as the top military officer, general of the United States Army. The new nation was experiencing difficulties with the Indian confederation on the northwest frontier between the Ohio River and the Great Lakes. General Wayne retrained the army and, in 1795 through some decisive battles, gained peace for that region. In 1796, after a brief visit back home in Chester County, Wayne journeyed to the frontier region to inspect the forts and enforce the treaty, meeting peacefully with both the settlers and the Native Americans. After visiting forts in the Detroit area, he boarded a ship to sail across Lake Erie to Fort Presque (now Erie, Pennsylvania). On the voyage, he suffered a severe attack of gout. (In Wayne's time, gout was a common ailment. Some thought it was caused by eating too much rich food and wine, but we now understand that it was a form of kidney failure, which could be

fatal if untreated.) Once ashore, General Wayne was cared for in a blockhouse of the fort. His friend and military surgeon Dr. James Wallace was sent for, but Wayne died before Dr. Wallace arrived from Pittsburgh. At the general's request, he was buried in full uniform in a simple casket under the flagpole at the northwest blockhouse. The leather-topped casket was embellished with brass nails that formed the inscription "AW ob Dec 15, 1796."

In 1808, the Pennsylvania legislature discussed interest in erecting a monument honoring the great general. Anthony Wayne's son, Isaac, then a state senator, decided to travel to Erie to retrieve his father's bones for reburial at the family site at Saint David's Episcopal Church in Radnor. For ease of travel on the four-hundred-mile journey, Isaac used a sulky—a small two-wheeled carriage—with a modest wooden box attached to the rear to transport the bones of General Wayne. From one end of the state to the other, the journey took several days. When he arrived in Erie, Wayne contacted his father's friend, Dr. Wallace, who had settled in Erie after retiring from military service. They had the body exhumed, only to discover that the remains of General Wayne were remarkably well preserved. Much of his uniform was gone, and one leg had decomposed, as expected, but the rest of the body, including much of the flesh, was still intact. The wooden box on the sulky would not be big enough to carry the remains.

Dr. Wallace volunteered to prepare the bones for travel. After separating as much as he could, he boiled the remains so that the flesh could be removed from the bones. The bones were then carefully placed in the small box on Isaac's carriage, while the water, remaining flesh and surgical tools were placed in the original casket and reburied at the fortification. Isaac Wayne returned to Chester County with the bones of his father. Soon the Society of the Cincinnati erected a monument at Saint David's Church with the following inscription:

> *In honor of the distinguished Military service of Major General Anthony Wayne And as an affectionate tribute of respect to his memory, this stone was erected by his companions in arms. The Pennsylvania State Society of the Cincinnati July 4, 1809, the thirty-fourth anniversary of the Independence of the United States of America, an event which constitutes the most appropriate eulogium of an American soldier and patriot.*

# The Nineteenth Century

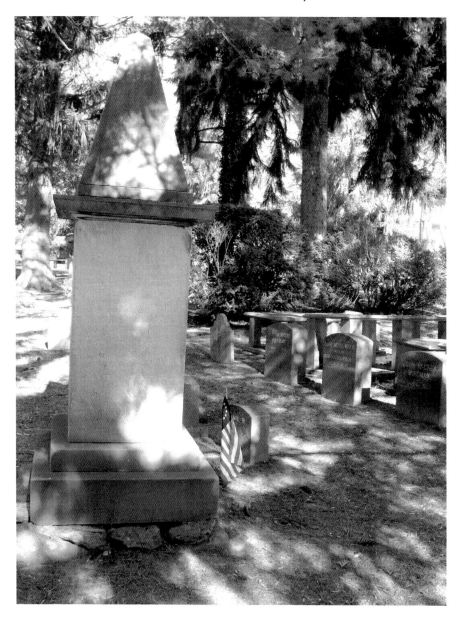

The bones of Anthony Wayne were reburied at Saint David's Episcopal Church in Radnor, and this monument was erected by the Society of the Cincinnati. *Photograph by Genny Gallagher.*

Anthony Wayne has the unusual distinction of being buried in two places. The well-maintained burial site at Saint David's Church looks much like it did when the monument was erected in 1809. The fort at Presque Isle was abandoned and fell into disrepair. Local residents were well acquainted with the story of General Wayne's burial, exhumation and reburial, but the location of the grave was lost until 1874, when a hunter of historic relics located a casket with its leather top and brass-tacked inscription. After a few years of discussion, the Pennsylvania legislature reconstructed the blockhouse as a memorial to the early fort and erected a plaque with the inscription:

> *This is the original tomb of General Anthony Wayne who died here in 1796. Twelve years later his bones were lifted and taken to the Wayne burial plot at Saint David's churchyard in Radnor near Philadelphia. In 1875 the state legislature appropriated money to build this blockhouse near his original grave.*

*Notes: News clippings from CCHS. There are many ghost stories associated with General Anthony Wayne. As one might imagine, along with this unique story of burial and reburial, stories have appeared in several places in Pennsylvania, as well as at other Revolutionary sites. An excellent source for the many ghostly tales is Charles Adams's book* Ghost Stories of Chester County and the Brandywine Valley. *Anthony Wayne's stately mansion, Historic Waynesborough, is open to the public.*

## Thy Friend Pot

In 1818, potters Thomas and John Vickers were known throughout southeastern Pennsylvania for their opposition to slavery and their willingness to risk helping fugitive slaves. Rushing into his West Whiteland home one day, John Vickers excused his wife from the rest of the family and urgently whispered to her, "We must remove our visitors at once. Some angry slave hunters are at this moment searching my father's house. It will not be long before they come this way." Abigail quickly climbed into the attic and urgently passed on the message. While John kept watch at the

# The Nineteenth Century

Abolitionist John Vickers was an agent on the Underground Railroad. *Uwchlan Township Historical Commission.*

front door, two freedom seekers were escorted out the back and sent into the woods. They had been provided with food and fresh clothing. They would be driven by John's black teamster, David Countee, north to the home of John and Esther Lewis near Kimberton.

Countee saw the freedom seekers coming toward his home and immediately knew what to do. He hitched his team to the big blue wagon used to deliver Vickers Pottery throughout the region. Countee's delivery wagon was special. Below the floor of the wagon was a secret compartment. David urged the fugitives to climb into the cramped space. Then he began the drive to the Lewis farm near Kimberton. John and Esther Lewis would take care of them at their home and find a way to forward them farther north.

In a short time, three men rode their horses into the yard of John Vickers, who greeted them politely, but the men gruffly demanded entrance to hunt for their fugitive slaves. Stalling for time, John said, "It will be of no use to search my house, for I know that there are no fugitives in it." The pursuers insisted that they search every room in the house from attic to cellar. John accompanied them everywhere, quietly insisting that they would find no one.

The more John talked, the more insistent they were. They searched through closets and storage chests in the attic. They moved crates and barrels in the cellar. When no one was found, they searched all the pottery buildings, the kiln, the drying shed and surrounding wood piles. Meanwhile, the freedom seekers were adding more distance between themselves and their pursuers. When they had searched every building without success, the disappointed slave hunters finally left, one of them making the caustic remark, "We might as well look for a needle in a haystack as hunt for a Negro among Quakers."

John Vickers—and his father and grandfather before him—had helped slaves seek freedom for years, well before the Underground Railroad became popular. John was quite resourceful. He employed black workers in his pottery business and relied on their assistance in hiding fugitives in their homes and transporting slaves from one station to the next. Fugitives came to him from several different routes, and he sent them on to Kimberton, Phoenixville or Philadelphia. Vickers Pottery owned several large blue delivery wagons, which were often seen day and night on the local roads, traveling to and from Philadelphia and Wilmington. Few people realized that some of those wagons had false bottoms used to hide fugitives. John often wrote notes with coded messages to his fellow stationmasters, signing the notes "Thy Friend Pot." In sixty years as a stationmaster, John Vickers helped more than one thousand freedom seekers, and no fugitive slave who came into his hands was ever recaptured.

*Notes: Smedley,* History of the Underground Railroad, *248; news clippings from CCHS; Brody,* Constant Struggles, *5.*

# Duffy's Cut

In 1828, the Pennsylvania legislature authorized the creation of the Philadelphia and Columbia Railroad, connecting Philadelphia at Broad and Vine Streets near the Schuylkill River to the Susquehanna River at Columbia. Much of the eighty-two-mile-long railroad ran parallel to the Lancaster Turnpike. In 1834, the project was officially named the "Main Line of Public Works." (The name "Main Line" is still in popular use

# The Nineteenth Century

Mile fifty-nine of the Philadelphia and Columbia Railroad was known as Duffy's Cut. *Photograph by Genny Gallagher and Jack Stapleton.*

today.) Construction began in 1830. By 1832, the first twenty miles from Philadelphia to Paoli were completed and opened for use. In the summer of 1832, construction began on mile fifty-nine a short distance west of Paoli near what later became Malvern. Construction was a challenge in this area because of some steep slopes and gullies. The railroad workers had to dig through hills and fill in valleys to make the land level enough to lay the tracks.

An Irish immigrant, Philip Duffy was a construction contractor hired by the railroad to employ and supervise laborers to prepare and install the railroad bed. On June 23, 1832, Duffy was at the dock in Philadelphia, awaiting the arrival of the ship *John Stamp*. The ship had sailed from Londonderry, Ireland, on April 24. As soon as the passengers disembarked, Duffy hired several Irish men for the railroad construction project. According to the ship's passenger list, the laborers included George Doherty, John Ruddy, William Putetill, William Devine, James Deveney, Daniel McCahill, Bernie McGarty, David Patchill, Robert

Skelton, Patrick McAnamy, Bernard McIlheaney, George Quigly, Samuel Forbes, John McGlone and John McClanon. They ranged in age from eighteen to twenty-eight. Several more from this ship probably joined Duffy's workforce, but the names cannot be confirmed.

Duffy immediately transported the new immigrants to Chester County, where they may have joined other Irish men who were living at the house that Duffy rented in Willistown. Altogether, fifty-seven strong young men were ready to begin work on mile fifty-nine, paid at a rate of fifty cents per day plus room, board and a ration of whiskey. A temporary shelter was built on the eastern side of the ravine to accommodate them. Camaraderie quickly developed, for although they came from different parts of Ireland, they were all strangers in a new land. Local residents kept their distance due to prejudice against immigrants in general and Irish Catholics in particular. Using pickaxes, shovels, iron wedges, sledgehammers and wheelbarrows, the men began to dig through the rocky hillside, carting stone and dirt to fill in a trench more than twenty-five feet deep. The area dug out was called the "cut," while the man-made embankment was called the "fill."

The original rails were Morris and Essex Welsh iron rails imported from England. At first, the rails were laid on wooden sills, but after the steam engine came into common use, the rails were supported on stone blocks. (Years later, the treated wooden rail ties on a gravel bed that we know today came into popular use.)

After a few weeks of strenuous manual labor, the "cut" was nearing completion when some of the men got sick with a dreaded disease: cholera. In the summer of 1832, southeastern Pennsylvania was experiencing a cholera epidemic. Cholera is an infection of the small intestine caused by bacteria in water. Symptoms include abdominal cramps, dehydration, nausea, vomiting, diarrhea, rapid heart rate and lethargy. Death is usually caused by severe dehydration. It is spread by drinking contaminated water or through direct contact with the body fluids of those infected with the disease, so good sanitation could keep others disease-free. However, people so feared the often fatal disease that they avoided all contact with victims. Many believed that the Irish were the ones who brought cholera to America.

At first, the only person to offer assistance was Malachai Harris, a local blacksmith who also worked for Philip Duffy. The first few men to die were

buried by the blacksmith in simple coffins in shallow graves. As more men became ill, they sought help from local residents, but they were turned away. No one wanted to risk getting the disease. Harris sent word to Duffy in Philadelphia. The Roman Catholic Church responded by sending four nuns from the Sisters of Charity. The sisters rode the stagecoach as far as the Green Tree Inn and walked to mile fifty-nine. They cared for the sick, but all of the men died. Fatalities usually numbered 40 to 60 percent in a cholera epidemic, so 100 percent is rare. Malachai Harris dug a large ditch in the railroad fill to use as a mass grave. After the first five victims, all of the rest were buried together. After the final death, the sisters sought transportation back to Philadelphia, but no one would help them because of their contact with the cholera-infested immigrants. They were forced to walk more than twenty miles back to the city with little water on a hot August day. Under orders from Philip Duffy, Harris burned the shanty and all of the Irishmen's belongings.

Construction on that part of the railroad was halted until cooler weather. Duffy reported delays and cost overruns on what turned out to be the most expensive mile on the railroad. There is no evidence that he was reimbursed for the additional costs. A few newspapers reported the trouble but downplayed the deaths. The railroad company tried to avoid any bad publicity. The following spring, Mr. Duffy was once more on the docks awaiting ships from Ireland to hire men for the railroad. The Philadelphia and Columbia Railroad project was completed in 1834. In 1857, the P&C was bought out by the Pennsylvania Railroad.

Early railroad records were lost, so information on the deaths of the Irish immigrants became part of local lore. For many years after the cholera outbreak, stories were told of ghosts being seen near Duffy's Cut. Many claimed to have seen ghosts dancing around the mass grave. Suspicions also arose that some of the men might have been killed by vigilantes, but there was never any proof. Tales of ghosts and vigilantes were passed down from one generation to the next. In 1870, a sympathetic Irish railroad worker heard the story and enlisted help from others to enclose the grave. Many laborers donated fifty cents each, and the funds collected were used to erect a wooden fence around what was thought to be the grave site.

In 1909, Martin Clement, then assistant supervisor of the Paoli rail yard, replaced the deteriorated wooden fence. The new stone wall used old

stone blocks that had once supported the original 1832 rails. Mr. Clement gathered data on the 1832 incident. In 1933, he became president of the Pennsylvania Railroad. The railroad company had always been concerned about how this tragic event might be regarded by the labor force. Mr. Clement ordered that the information he had gathered be secreted away. The secrets remained hidden in a railroad file throughout much of the twentieth century, with only local lore to maintain the legend of the fifty-seven men who died at Duffy's Cut.

*Notes: Watson, Watson, Ahtes and Schandelmeier,* The Ghosts of Duffy's Cut; Immaculata *magazine, 7; news clippings and miscellaneous data from CCHS; interview with Dr. William Watson of the Duffy's Cut Project, www.duffyscutproject.com.*

# Ann Preston

Ann Preston grew up in a family of abolitionists. As a young woman, she joined the Clarkson Anti-Slavery Society, one of the nation's first organizations to welcome women as active members. Named for renowned British abolitionist Thomas Clarkson, the society held meetings in Chester and Lancaster Counties and offered programs by prominent speakers of the day, including William Lloyd Garrison, Charles Burleigh and Wendell Phillips. Ann's writing skills earned her some unusual opportunities within this and other organizations. She composed reports, addresses and petitions. Her parents were active participants in aiding freedom seekers along the Underground Railroad, and Ann followed their lead in helping fugitives move through Chester County. Ann was also an activist for temperance and woman's rights and eventually became one of America's first woman doctors. Because of the need for secrecy, much of the Preston family efforts in the Underground Railroad were not documented, but there are two stories that relate directly to Ann Preston.

One Sunday in the spring of 1836, Ann Preston was at home in West Grove eating breakfast with one of her younger brothers. Their parents were away at the Society of Friends Quarterly Meeting, leaving Ann with a freedom seeker hidden in the attic. Ann did not go to the nearby Quaker

# The Nineteenth Century

Ann Preston was an activist in abolition, temperance and woman's rights. *Chester County Historical Society, West Chester, Pennsylvania.*

meetinghouse that morning because she worried about leaving the woman alone. At the sound of hoofs in the drive, Ann looked out the window and saw her neighbor, John Jackson, riding quickly down the lane. Ann moved out to the porch as Mr. Jackson pulled up. He informed her that slave catchers were searching his home and farm and would soon be at the Preston farm. Mr. Jackson then took off to spread the news to others in the neighborhood.

Ann knew that she needed to quickly move the woman to safety, but she worried that there was not enough time. She told her little brother to bring the woman down from the attic to their parents' bedroom and then go to the kitchen and pack a basket of food. Ann dressed the woman in her mother's clothes, putting a Quaker bonnet on the woman's head. The brim was very large, covering the woman's face. She also gave her a very large shawl to wrap around her shoulders. They descended the stairs and took the basket of food. Ann hitched the horse to the farm wagon and told the woman to sit on the bench and keep her head down. Ann bid her brother farewell, telling

him to run to another farm, where he could be safe. Then she boarded the wagon and drove up the farm lane to the road. No sooner had they turned onto the road toward the New West Grove meetinghouse than three men approached on horseback and blocked the way. They searched the back of the wagon and asked where they were going. Ann replied that they were on their way to the Quaker meetinghouse down the road. The slave catcher took a long, serious look at both Ann and the other woman and then replied, "They've already begun, you'll be late."

Moving out of the way to let Ann proceed, the men continued on their way toward the Preston farm. As soon as the men were out of sight, Ann drove the wagon to the Jackson farm, which had already been searched. The woman was hidden there until Mr. Jackson returned and found a way to move her along to another station. Once more, the Prestons and Jacksons had assisted a freedom seeker on her journey to freedom. Ann Preston was twenty-two years old when this occurred. At that time, she was a teacher and a published poet. Using assumed names, she wrote a thirty-verse poem, "Ruth, The Ballad of 1836," relating her personal account of the incident. Her story poem was published in 1836 in an abolitionist publication.

In another incident in the 1840s, Ann and her friend Elizabeth Coates were given the responsibility of conducting a fugitive family from the Preston farm in West Grove to James Taylor in Marlborough. They usually tried to move at night, but that was not always possible. After receiving word that slave catchers were moving north from Delaware, Ann and Elizabeth had the family of three lie down on the floor of the farm wagon. They were covered with blankets and instructed to be silent. No one suspected that there were fugitives hiding under the blankets because the two young women leisurely drove the wagon several miles to Mr. Taylor's farm in the middle of the afternoon, waving to friends and neighbors as they passed.

*Notes: Brody, "Ann Preston," 7–8; Smedley,* History of the Underground Railroad, *248; news clippings and miscellaneous data from CCHS.*

# The Nineteenth Century

## Flight to Freedom

Rachel was born a slave in the early 1800s. She lived in Maryland and was owned by a man named Mort Cunningham. Rachel grew up to be a tall, strong woman with a beautiful singing voice and a talent for storytelling. When Rachel was a young woman, her master offered the use of Rachel to a friend from Baltimore. Henry Waters and his wife were planning a trip to New Orleans by ship and wanted Rachel to be Mrs. Waters's servant during the journey. On the return voyage, Mr. Waters got sick and died. When the ship docked in Baltimore's harbor, arrangements were made to remove his body. In the general confusion of disembarking and unloading the ship, Rachel saw a once-in-a-lifetime opportunity. She disappeared into the crowd and ran away, making her way north and crossing the state line into Pennsylvania, where she was helped by abolitionists and hired by Emmor Kimber as a cook at his boarding school in Kimberton, Chester County.

Years later, she married Isaac Harris, another former slave. They lived in West Chester, where Isaac worked at the Sharples brickyard. Rachel operated her own laundry service. Her skills and dependability brought success to her business. She had many loyal clients. The Harris home was a small, tidy house on West Miner Street between Darlington and New Streets, near Everhart's Grove. On warm summer evenings, Rachel could often be found sitting on her front step, her voice raised in song.

After years of a peaceful, successful life, Rachel thought she was both free and safe. She shared with her friends and neighbors the harrowing story of her journey from slavery to freedom. Rachel became very emotional as she described her years of slavery. She told of the hard life of a slave and the harsh cruelty of her original owner, Mort Cunningham. Rachel had personal proof of his cruelty—a twisted, broken and useless finger, broken by Cunningham when Rachel had not obeyed him quickly enough. Her life stories brought comments of sympathy and respect from her friends and neighbors.

In the 1830s, there were still many people in Pennsylvania who supported slavery. There were some who hunted and captured fugitives for the bounties offered by slave owners. Someone in West Chester checked on Rachel's story and found out that Mort Cunningham was offering a

Rachel Harris operated a successful laundry business in West Chester. *Library of Congress Prints and Photographs Collection.*

reward for Rachel's return. The years had not mellowed Cunningham. He wanted his property and was willing to pay. Besides, the law was on his side. All he had to do was prove that Rachel had been his slave.

In September 1839, Cunningham journeyed to West Chester and enlisted help from the local constable. They went to the Harris house on West Miner Street. Rachel tried to escape, but she was captured and handcuffed. The constable insisted that Cunningham could not just take Rachel away. They proceeded up Miner Street to Church Street to the home and office of Judge Thomas Bell. Judge Bell was a prominent West Chester Quaker who opposed slavery. However, his position as judge required him to uphold the law. The law of the times stated that a slave owner could retrieve his property. Not much proof was needed to satisfy the law. Rachel vowed that she would never be enslaved again. She would rather be cut to pieces than return to slavery. Now she was held captive by the very man who had treated her so cruelly all those years ago.

Judge Bell slowly and deliberately examined the paperwork provided by Cunningham. Finally, the slave owner grew impatient and grabbed Rachel's hand, showing the judge her mutilated finger to prove that she belonged to him. For Rachel, the touch of Mort Cunningham was too much to bear. Feigning illness, she asked to be excused to go to the outhouse in the backyard. A seven-foot fence surrounded Judge Bell's back garden. The old constable escorted Rachel to the yard, removed the handcuffs and stood by the back door, offering her a little privacy. Rachel quickly regained her strength. Instead of walking to the outhouse, Rachel ran through the garden and leaped toward the high fence. As if assisted by an unseen hand, she scaled the fence and disappeared, leaving the startled constable to return to the judge's office and report the escape.

West Chester was crisscrossed by alleys that provided access to the liveries and carriage houses for the buildings on the main streets. Rachel ran through the alley, up Miner Street to High Street and then up High Street to the alley near Samuel Augee's Hat Shop. She ran through the alley, leaping over a huge vat of boiling chemicals, surprising the hat shop workers, and racing into the alley behind Market Street, finally coming to the home of Mr. and Mrs. John Worthington, a laundry client of Rachel's. Rachel knocked on the Worthingtons' back door and pleaded with Mrs. Worthington to hide her.

The West Chester Dance Works presented the story of Rachel Harris in dance. *Image designed by Iwona Piatkowska. Courtesy of Diane Matthews of the West Chester Dance Works.*

At first, Mrs. Worthington refused, not believing Rachel's story, but seeing Rachel's distress and hearing the panic in her voice, Mrs. Worthington escorted Rachel up to a closet in the attic.

Meanwhile, a frustrated constable returned to the judge's office to report Rachel's escape to Judge Bell and Cunningham. They raced out to Miner Street and asked a man if he had seen Rachel. That man sent them in the opposite direction from which he had seen Rachel run. They searched the streets of West Chester until late in the afternoon, when they heard a story about someone flying through the hat shop in a hurry. They searched the alley behind the store, asking John Worthington if he had seen the woman. He told them he had not. The hunt continued well into the night. When Mr. Worthington entered his home, his worried wife described the crisis. They were able to reach Rachel's husband at the Sharples brickyard. Isaac's boss,

# The Nineteenth Century

Philip Sharples, contacted his friend, Benjamin Price, whom he knew to be an active abolitionist and an agent on the Underground Railroad. That night, a carriage pulled up to the Worthingtons' front door. Two men entered the house. A short while later, three men were seen leaving the house and boarding the carriage. Rachel had been dressed in men's clothes. She and Isaac were driven through the rainy night to Norristown and then up into Bucks County, where they were sheltered for a few days until arrangements were made to move them on to Canada. They left behind their home, their possessions and their friends. Years later, Rachel wrote to her friend, Hannah Jefferies. She described her flight and told her friend that she was happy. She and Isaac had found freedom, work and new friends in a colored community in Canada.

*Notes: Diane Matthews of West Chester Dance Works; Brody,* Constant Struggles, *16–17; news clippings and miscellaneous data from CCHS.*

## THE BATTLE AXES

An unusual religious group known as the Battle Axes came to Chester County in the 1840s. Its followers believed in free love, nudity and freely sharing all possessions. The group was established in 1837 when religious zealot Theophilus Gates of Philadelphia published a newsletter called *Battle Axes and Weapons of War* explaining his beliefs. The title (originating from a biblical quote) is rather misleading; the Battle Axes believed in love, not war. Theophilus Gates was a strong, charismatic religious leader, similar to some of the cultists of the late twentieth century. He urged followers to abandon marriage even though he was married. He believed that commitment to another human diminished one's commitment to God, while sexual relations without attachment were free expressions of God's love. Material possessions were unimportant and should be shared with everyone. Shedding one's clothes brought the worshippers closer to Adam and Eve in the Garden of Eden.

He was soon joined in his religious evangelism by an equally strong and dynamic woman, Hannah Williamson. Hannah was born in Dilworthtown

to devoted Quakers. As a young woman, she rebelled against what she believed to be the strong behavioral constraints of her Quaker upbringing and moved to Philadelphia, earning her living in the world's oldest profession. At about the same time that Hannah and Theophilus were connecting in Philadelphia, Hannah's sister, Lydia, was serving time in a New York prison for marrying a colored man, but once she was freed she joined the Battle Axes. Theophilus's wife, Mary, was also an active participant in the Battle Axe movement.

Many of the Battle Axe followers were women. They opposed marriage, wearing clothes and falling in love. Their ideas on free love were rather self-centered. Women who followed this so-called religion tended to select temporary mates based on their own desires, which often differed greatly from the thoughts of the proposed mates' current wives.

Theophilus and Hannah met with some opposition in Philadelphia, so they moved to North Coventry Township. Theophilus and his wife, Mary, lived at the home of Battle Axe convert Samuel Reinhard. Theophilus brought several followers to a northern Chester County retreat and welcomed converts from the local community. They created quite a stir in the neighborhood, invading homes, preaching at churches and parading in the nude. They were known to have marched naked, singing and waving their arms, into the sanctuary at the Shenkel Church, the Temple Methodist Church and the Bethesda Baptist Church. The Battle Axes often gathered at the springhouse on the property of Hannah Shingle, in the barn of George Snyder and at the pond on Cold Springs Road near the border between Berks and Chester Counties. The location was known locally as Schenkel Valley but was renamed "Free Love Valley" by area residents. Many were mildly amused by the group's activities, but those closest to the members found their behavior offensive and a little frightening.

It was common practice that a Battle Axe would arrive at someone's home and announce that God had inspired her to mate with the man of the house. The original wife could stay if she chose and serve as housekeeper, or she was free to go find another mate for herself. Most families accosted in this way rejected the advances, but there were some who embraced the idea. One Christmas Day, the Mullens of Phoenixville were visited by a Battle Axe who appeared at the Mullen house clad only in a long black cape. She informed

# The Nineteenth Century

Mrs. Mullen that God had told her to present herself to Mr. Mullen. Mrs. Mullen should not have had much to worry about, as Battle Axes rarely stayed with one person for long. In contrast, Magdalene Snyder successfully replaced William Stubblebine's wife and their six children. Beginning in 1841, William and Magdalene's relationship lasted nearly thirty years. They are both buried at the cemetery at Shenkel Church. Hannah Shingle was another convert who hosted meetings at her springhouse. According to local lore, Hannah still haunts the springhouse and the cemetery at Shenkel Church.

Legal battles followed the Battle Axes throughout the 1840s. Once, when the Battle Axes were bathing nude at the Cold Springs Road pond, an angry Berks County constable, Billy Rhoads, chased the bathers off with a bullwhip. Later, several were arrested and charged with adultery and indecent exposure. In February 1843, the courtroom in West Chester was packed with observers who hoped to be entertained by the titillating trial testimony. Since the Berks County constable had entered Chester County with his whip, Gates's legal counsel questioned his authority and threatened to bring charges against him for attacking innocent bathers. Ultimately, three Battle Axes were convicted. Daniel Stubblebine served eighteen months in jail for adultery (one of his partners was Theophilus's wife, Mary). Samuel Barde and Lydia Williamson (Hannah's sister) served four months each for fornication.

Theophilus Gates died in 1846 and was buried in the Reinhard family plot at Union Cemetery in Parker Ford, leaving Hannah in charge of the Battle Axes. They continued to live and agitate the community for several more years. Hannah lived with two brothers, who fathered her children. Unfortunately, both of her sons died soon after birth. Superstitions surround the graves of Hannah's sons. Hannah became more vocal in her preaching, sharing her beliefs and quoting the Bible wherever she happened to be. She was arrested several times for invading churches and disrupting worship services. One particular target was the Temple Methodist Church near Coventryville. The first visit was met with stunned silence, but she returned week after week. After being repeatedly asked to leave, Hannah was finally arrested and taken to jail. Eventually, Hannah moved on to greener pastures sometime in the late 1850s. Without a strong charismatic leader, the Battle Axes gradually faded into oblivion.

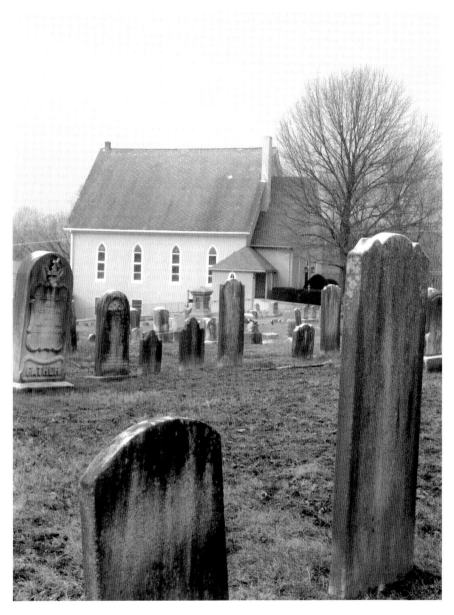

Some members of the Battle Axes are buried at the cemetery of the Shenkel Church. *Photograph by Genny Gallagher and Jack Stapleton.*

# The Nineteenth Century

*Notes: Futhey and Cope,* History of Chester County, *301; Wright, "Free Love and the Battleaxes," 45–49; Snyder, "The Battle Axes of Free Love Valley"; news clippings and miscellaneous data from CCHS; public records from the Chester County Archives.*

## Edward Hunter, Mormon Bishop

During the 1830s, there were several religious revivals and evangelical events in Chester County. One resident embraced a new religion and became a nationally recognized leader in the sect. Edward Hunter was born in Delaware County, Pennsylvania, in 1793, but in 1830 he bought a large farm in West Nantmeal Township in Chester County. He and his wife, Ann, lived on the farm for more than a decade. Hunter was one of the wealthiest men in Chester County. When residents wanted to open a school in 1831, Hunter provided the land for the school under the condition that all religious groups were welcome to use the schoolhouse for worship.

The subscription school was called the West Nantmeal Seminary. In the spring of 1839, some missionaries from a new religious sect asked to use the building for their services. That new religious group was called the Church of Jesus Christ of Latter-Day Saints, better known as Mormons. At first, the school directors refused because they considered this new group to be dangerous, but Hunter reminded them of the conditions of the school lease. He threatened to reclaim the land and the school building, so the directors relented. For several months, the Mormon missionaries Elijah Davis and Lorenzo Barnes held meetings and worship at the West Nantmeal Seminary. Many families began to attend the worship services and converted to the Mormon faith. The founder of the Mormon faith, Joseph Smith, visited during the winter months of 1839–40, staying at the home of Ann and Edward Hunter. As many as two hundred Chester County residents converted, causing some in the community to refer to the West Nantmeal neighborhood as "Mormon Valley" or "Mormon Hollow."

Although Edward Hunter had never been a very religious man, he embraced the new religion. He often spoke of revelations that came to him at night and stated that the religion made sense to him in a way that he had never experienced before. In 1842, he sold his lands and, with his family

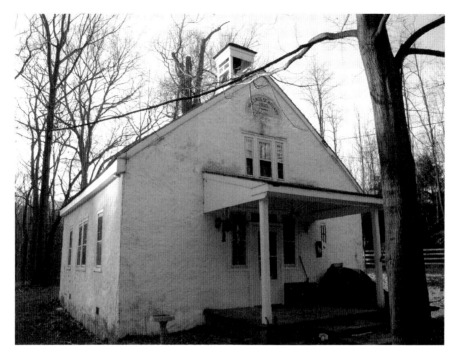

The West Nantmeal Seminary, at which Mormon missionaries preached, was renamed when the land became part of Wallace Township. *Photograph by Jack Stapleton.*

and several others, moved to Nauvoo, Illinois, a town built by the Mormons. Under the guidance of Brigham Young, Hunter became a respected leader and was named to be the bishop of Nauvoo's fifth ward. He also served as a bodyguard for Joseph Smith, who was often in danger due to his preaching. In 1844, Joseph Smith was killed by an angry mob in Carthage, Illinois. The Hunters did not stay in Illinois long after Smith's death but instead moved to Iowa and then to Nebraska.

After Joseph Smith's death, Brigham Young took over as the presiding bishop of the Mormons and later became president. He led the group on the great migration west, where they eventually settled in Salt Lake City, Utah. Between 1847 and 1868, sixty thousand Mormons traveled west in three hundred wagon trains called companies. Hunter was the leader of one of the first companies that left Winter Quarters, Nebraska, on June 17, 1847, and arrived in Salt Lake City on September 29. That first company had nearly two hundred people in seventy-two wagons.

# The Nineteenth Century

For a few years, Hunter returned to Nebraska to lead other companies west, assisting those who were too poor to finance the journey on their own. Many Mormons kept journals of their journey. Hunter recalled traveling a trackless course, meeting up with many Indians and trading cheap trinkets for buffalo robes and moccasins. He was often sick during the journey but remarked excitedly that he saw something new every day. One of his fellow travelers, Jane Gardner Bradford, described seeing the hills and vales black with millions of buffalo.

In 1851, President Young named Edward Hunter to be the presiding bishop, assisted by two counselors. The bishops were responsible for the everyday working of the church, including responsibility over members' tithes, construction of places of worship, developing church programs and caring for the poor. In 1853, Bishop Hunter laid the southwest cornerstone for the Salt Lake Temple. In 1876, despite fragile health, eighty-four-year-old Hunter returned to Pennsylvania. He visited family members in Chester County and Philadelphia and enjoyed the Centennial Exhibition. Bishop Hunter was described by followers as honest, kind, caring, generous, shrewd and humble. He was loved by all and enjoyed a long term as presiding bishop, thirty-two years, until his death in 1883 at the age of ninety.

*Notes: News clippings and miscellaneous data from CCHS; Church of the Latter-Day Saints, http://www.lds.org/ldsorg (search for "Edward Hunter").*

## THE SWEDISH NIGHTINGALE VISITS YELLOW SPRINGS

Yellow Springs was a health spa as early as 1722. For more than a century, it was known for the healing powers of the mineral springs. The iron spring, sulfur spring, magnesium spring and the springs of pure drinking water were all recognized for their restorative capabilities. For more than fifty years before and seventy-five years after the American Revolution, the Yellow Springs plantation housed a successful commercial health resort. In 1810, a writer praised the springs as a rural retreat that combined many advantages for invigorating the system, relaxing from fatigues and restoring declining health.

Jenny Lind visited Yellow Springs when she toured Pennsylvania. *Library of Congress Prints and Photographs Collection.*

In the years before the Civil War, Yellow Springs was a popular resort. Transportation to the springs was provided by coach from Philadelphia, as well as from nearby towns such as Downingtown and Phoenixville. Many people traveled from Philadelphia and as far away as New York to enjoy the springs and the entertainments that were provided at the two hotels. Musical recitals and lectures were popular. A famous attraction came to Yellow Springs in 1836 when the Siamese twins Cheng and Eng appeared at Mrs. Holman's hotel. Tickets cost twenty-five cents for both the afternoon and evening programs. The Siamese twins were later associated with the showman P.T. Barnum. Another notable accomplishment of Barnum's was arranging the American tour of the "Swedish Nightingale," Jenny Lind.

# The Nineteenth Century

Local tradition holds that Europe's famous opera singer came to Yellow Springs during the American tour of 1850–52. Most written documentation has not survived, but there is considerable circumstantial evidence to support Jenny Lind's visit to Yellow Springs.

Jenny Lind was born in Stockholm, Sweden, in 1820 and was recognized for her vocal talent at an early age. From her professional debut at the age of seventeen, Jenny became the sweetheart of Europe. There was quite an extensive range in her clear soprano voice, and she demonstrated dramatic talents that highlighted her lyric roles. As she traveled through Europe, she often rested at health spas, finding the mineral baths restorative and a panacea to her hectic touring life.

In 1849, P.T. Barnum heard about her and became determined to bring her to America. He thought that sponsoring Jenny Lind in concert would improve his image as a man of culture. He sent an agent to negotiate a contract, which resulted in Barnum agreeing to pay Lind $1,000 per appearance. That was a remarkable sum considering that Barnum himself did not actually hear her voice until her first American concert. The concerts proved to be financially profitable for both of them, although they parted ways in June 1851. Jenny began her American tour in September 1850 and continued through May 1852 before she returned to Europe. Audience attendance at times reached five thousand. During her twenty-one-month tour, Jenny appeared in Philadelphia at least five times: October and November 1850, June and December 1851 and May 1852. She and Barnum did not have a good relationship, so she looked for respite from his overbearing personality. It is quite possible that she sought rest and relaxation at Yellow Springs during those times when she was in the Philadelphia area.

At the height of her fame, people were so enchanted by Jenny Lind that they often named places and things for her. In honor of her visit, one of the springs was named for her, and one of the guesthouses in the village also bears her name. Through the years since, many have claimed that Jenny not only enjoyed the curative powers of the springs but also presented a concert there. The most likely concert appearance of Jenny Lind at Yellow Springs was May 1852, shortly before she sailed back to Europe. A 1974 article mentioned a Jenny Lind concert ticket for May 1852 as proof of her visit and performance. Unfortunately, thirty-five years later, no one can find that

The Jenny Lind Spring at Historic Yellow Springs was named in honor of the famous singer. *Photograph by Susannah Brody, with permission of Historic Yellow Springs.*

ticket. We are left with the legend that the Jenny Lind Spring House and the Jenny Lind Guest House were reminders of the American tour of one of Europe's finest singers.

*Notes: Cavanah,* Jenny Lind's America; *news clippings and miscellaneous data from HYS.*

## Kidnapped!

Sisters Rachel and Elizabeth Parker were free blacks, born and raised in Chester County, Pennsylvania. Their parents were Rebecca and Ned Parker. Both parents were from the free black population of eastern Lancaster and western Chester Counties. Rebecca "Little Beck" Chandler married Edward "Ned" Parker in 1833. They had three children: Rachel, James and

# The Nineteenth Century

Elizabeth. Ned was not an ideal husband. He was often out of work and he drank a bit. Little Beck was a reliable laundress and housecleaner who worked for several families in the Nottingham area. In 1844, Ned left the family, taking his young son James with him. Little Beck arranged for the girls to work. In those days, it was not unusual for black girls as young as seven or eight to live and work on local farms.

At the age of eight, Rachel's first employment was at the farm of James Smith. When she was ten years old, she went to live at the farm of Joseph Miller, doing housework and earning her room, board, clothing and, occasionally, a little pocket money. She was steady and reliable like her mother. After working for the Millers for six years, Rachel was almost considered to be part of the family.

In contrast, Elizabeth was more like her father—lazy and not dependable. She was eight when she began to work, moving from one place to another. When her mother tried to influence her to become more reliable, Elizabeth took off. By the fall of 1851, eleven-year-old Elizabeth had found work for herself at the farm of Matthew Donnely. Early in December, she disappeared. There had been no family contact since the dispute with her mother months before, so no one learned of her disappearance. Mr. Donnely did not report it.

Thomas McCreary of Wilmington, Delaware, delivered mail to some of the area post offices in southern Chester County, so he was known to residents of Nottingham. On December 30, 1851, he paid a visit to the Miller house. When Rachel appeared in the kitchen, McCreary grabbed her and pulled her out the door. Mrs. Miller tried to stop him, but she was no match for his strength. He dragged Rachel out to the road, where another man, John Merritt, was waiting with a horse and buggy. Mr. Miller heard the commotion and chased after the buggy. As he cut across the fields to catch up, a neighbor, James Pollock, was traveling the same road with his large farm wagon and blocking the road. McCreary jumped out of the buggy, threatening Pollock with a bowie knife and ordering him out of the way. The kidnappers headed for the safety of the Maryland line. Miller and Pollock quickly spread the word, and a posse was formed to track down the kidnappers.

McCreary and Merritt fled south through Chrome, passed the Brick Meetinghouse, Cedar Farm, Farmington and Port Deposit to Havre

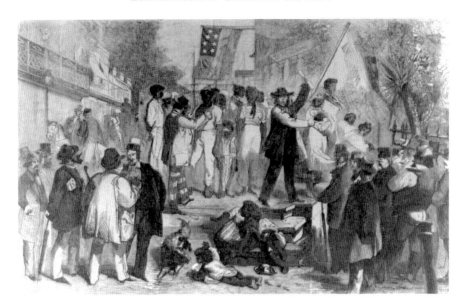

Sisters Rachel and Elizabeth Parker were brought to a slave market in Wilmington, Delaware. *Library of Congress Prints and Photographs Collection.*

de Grace, where they caught a train to Baltimore. They took Rachel to Campbell's Slave Market on Pratt Street. The next day, Joseph Miller, William Morris, Samuel Pollock, Lewis Melrath, Jesse Kirk and Hart Coates traveled to Baltimore, tracing the route of the kidnappers. They sought the help of Quaker Francis Cochran, who unsuccessfully attempted to persuade Campbell to release Rachel. However, because of the dispute, Campbell could not sell Rachel, so she was put in jail until the matter was resolved.

Meanwhile, Mrs. Miller and Rachel's mother went to check on Elizabeth, only to learn that she had also been taken by McCreary two weeks before. Mr. Donnely admitted that he had not reported her being taken because McCreary had convinced him that Elizabeth was a fugitive slave. Elizabeth had been taken to Campbell's Slave Market and sold, along with several other slaves, to a slave merchant who took her to New Orleans. She was resold for $1,900 to Madam Chero.

A warrant was issued for Thomas McCreary, and he was arrested. After a three-day hearing, McCreary was released because he convinced the magistrate that he really believed that the girls were former slaves. A petition in freedom was issued for Rachel. Elizabeth was returned to Baltimore from

# The Nineteenth Century

New Orleans and awaited a hearing in the same jail as Rachel. Elizabeth was not happy with this; she had been treated well and had enjoyed her brief but exciting visit to the Crescent City.

With the girls secure, if unhappy, in jail, nothing more could be done until a hearing was scheduled, so Mr. Miller and the four others boarded a train to return home. Mr. Cochran warned them to keep together, as they were in a hostile environment in a slave state. Mr. Miller stepped out onto the train car's platform to smoke a cigar. In just moments, the others realized, he was gone. They searched the entire train, but there was no sign of Miller or Tom McCreary, whom they had seen boarding the same train. When the train stopped at Stemers Run, two of the men headed back to Baltimore to hunt for Miller, while the others continued home to report his disappearance.

Joseph Miller was found the next day, hanging from a bush near Stemers Run. The Pennsylvanians realized just how hostile Marylanders could be when they could not obtain a coffin or wagon from undertakers or liveries to return the body home for burial. One of them walked several miles to the north to hire a wagon to take Miller's remains home. They retrieved the body and started back toward Nottingham, but a short distance from the state line an officer with orders from Maryland's governor stopped them and took the body back to Baltimore for an autopsy. The next day, a Baltimore newspaper stated that Miller had apparently committed suicide, but the evidence strongly disputed that theory. Once Miller's family was permitted to claim the body, a second autopsy was performed in Pennsylvania. Two Oxford doctors examined the remains. There was evidence that Miller had been both handcuffed and shackled. Pliers or a similar tool had been used to hold his nose. The stomach showed traces of arsenic. Despite the evidence, Marylanders clung steadfastly to the theory of suicide.

Rachel and Elizabeth sat in jail for more than a year while plans continued for gaining their release. The petition in freedom was initiated for Rachel, but if it was successful Elizabeth would also be freed. With the full support of the state legislature, the Pennsylvania governor appointed Attorney General Campbell to join Chester County judge Thomas Bell in presenting the case, assisted by Maryland attorney W.H. Norris. Three men—William Schley, Otho Scott and William Preston—composed the counsel representing slave owner Mrs. Dickehut of Baltimore, Maryland. According to court records,

Thomas McCreary was her agent hired to retrieve her fugitive slaves. Mr. McCreary claimed that even though he had known for years that Rachel lived with the Millers, he still thought the girls were Mrs. Dickehut's runaways. The main focus of the petition in freedom was identification. It was necessary to prove that the girls were not fugitive slaves.

After the death of Mr. Miller, scores of friends and neighbors volunteered to help. Young and old, black and white, throughout southern Chester County people willingly bore the cost of traveling to Baltimore and facing angry crowds of southerners. When the hearing finally began in January 1853, seventy-nine Pennsylvanians were in Baltimore to testify. One witness after another described their knowledge of Rachel and faced cross-examination. Some were family, some went to school with her, some were neighbors and some knew her from her work at the Millers'. Each one stated that Rachel was who she claimed to be: a free black girl, the daughter of free blacks, born and raised in the free state of Pennsylvania. The opposition counsel could not discredit the testimony. On the fifth day of the trial, after testimony from forty-nine witnesses, Mrs. Dickehut's counsel surrendered. Their witnesses would not be called to testify or be cross-examined. While not admitting any fault on the part of their client or Mr. McCreary, they declared that they could not conquer the overwhelming wealth of evidence that Rachel was who she claimed to be. The jury ruled to free both Rachel and Elizabeth.

No charges were ever brought in the murder of Joseph Miller, despite an offer of a $1,000 reward. A grand jury in West Chester indicted Thomas McCreary for the kidnapping, but the governor of Maryland refused to extradite him. He lived in Wilmington, Delaware, for another twenty years, never returning to Pennsylvania. Nottingham neighbors learned that Matthew Donnely had worked with and was paid by McCreary to hire Elizabeth so that she could be taken, but no charges were ever brought against him. The trial cost the Commonwealth of Pennsylvania more than $3,000. Widow Rebecca Miller, along with her young children, continued to live on the Miller farm near Nottingham. On her return to Pennsylvania, Rachel worked for Mark Coates for several years before marrying Mr. Wesley. Elizabeth moved on to northern Chester County and had no further contact with her family. Years later, she married Mr. Miller and lived in West Chester. In 1892, shortly after her father died, Elizabeth Parker Miller

gave an interview to a local newspaper, detailing her story of the kidnapping and trial. Strong opinions existed on both sides of the Mason-Dixon line, alienating residents of Pennsylvania and Maryland for years.

*Notes: News clippings and miscellaneous data from CCHS.*

## THE 1852 WOMAN'S RIGHTS CONVENTION

In July 1848, five women met in Seneca Falls, New York, to organize the first woman's rights convention. More than three hundred women and men attended the first convention and passed eleven resolutions stating that women had a natural right to equality in all spheres. In the next few years, women and men gathered to support those resolutions and propose their own. Lucretia Mott of Philadelphia was one of the five original organizers. Lucretia was a prominent Quaker who, with strong support from her husband James, worked diligently to promote the goals outlined in that first meeting. Lucretia hoped to plan a convention in Philadelphia, but threats from opposition groups discouraged city planners. In 1852, her Quaker friends in Chester County were able to organize a convention in West Chester.

Hannah Darlington, a quiet Quaker from rural Chester County, was the unlikely planner of this historic meeting. Hannah's organizing skills had been honed at antislavery and temperance meetings. She was elected secretary of the national woman's rights campaign at a similar convention held in Massachusetts in 1849. Hannah was modest about her talents and expressed concerns about the proposed convention. If the meeting was not successful, it could negatively affect the woman's rights movement for years to come. Hannah need not have worried. Many Quakers from southeastern Pennsylvania were enthusiastic supporters of Hannah's efforts. The first announcement of the convention appeared in the newspapers in April, giving ample time to those wishing to attend. The woman's rights convention was to be held in the Horticultural Hall in West Chester on June 2 and 3, 1852. "The Friends of Justice and Equal Rights are earnestly invited to assemble in convention, to consider and discuss the present Position of Woman in

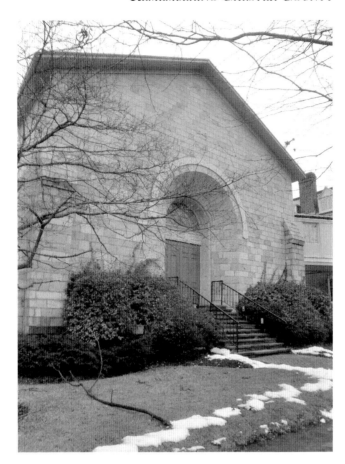

Pennsylvania's first Woman's Rights Convention was held at Horticultural Hall in West Chester. *Photograph by Susannah Brody.*

Society, her Natural Rights and Relative Duties." The invitation was signed by thirty women and twenty men, many of them husbands of the women, and all were community leaders.

Horticultural Hall (now the site of the Chester County Historical Society) was an ideal location, with a seating capacity of several hundred. It had been built in 1848, designed by Thomas U. Walter. Several examples of his work can be found in West Chester, but he is probably best known for his designs of the wings and dome of the United States Capitol Building in Washington, D.C. Horticultural Hall was used for farm shows, lectures and entertainments. News reports indicated that the hall was very full for both days of the convention, even though visitors paid a ten-cent fee to attend the lectures on the second day.

# The Nineteenth Century

Lucretia Mott called the convention to order, expressing gratification that so many had come. Many were from the immediate area, but there were also several from distant parts of the state and representatives from other states as well. Letters of support were sent by some who could not attend, including Paulina Davis of Rhode Island, Sarah Grim of Vermont and Dr. Elizabeth Blackwell of New York.

Officers were selected: Mary Ann Johnson, president; Mary Ann Fulton, William Jackson, Sarah Miller and Chandler Darlington, vice-presidents; and Hannah Darlington, Edward Webb and Sidney Pierce, secretaries. Members were appointed to business, finance and education committees. The keynote speaker was Dr. Ann Preston. Just six months earlier, the West Grove resident had been a member of the first graduating class of the Female Medical College of Pennsylvania. Ann had been a close friend of Hannah Darlington's for years, so it was not surprising that Hannah asked Ann to speak. She knew of Ann's talents in writing and expressing her thoughts. Dr. Preston's address met with great praise, and a resolution was passed to publish the speech as an exposition of the principles and purposes of the convention.

During the two-day gathering, several resolutions were approved, including principles that many take for granted today:

> *Resolved, That women are entitled by natural right to equal participation with men in the political institutions required for the protection of the whole people, and that it is gross inconsistency, and glaring exercise of arbitrary power, to compel women to pay taxes, while they are not permitted a voice in deciding the amount of those taxes, or the purposes to which they shall be applied.*

The eloquent wording reflects the expressive language of the times and the strong feelings of the participants. This resolution proposed that women should be able to vote as well as hold elective office. Other goals included equal pay for equal work, equal opportunities for vocations, equality before the law without distinction of sex, wider educational opportunities, equal disposition of property rights, inheritance rights for women and laws allowing women to retain guardianship of their children. (Women have accomplished

equality in family rights and educational opportunities but are still working on achieving equal pay.) In the middle of the nineteenth century, many of these resolutions were considered quite radical.

The Pennsylvania woman's rights convention was declared to be a resounding success, but political and governmental activity of the 1850s led up to a national crisis, the Civil War. Women suspended their campaign for equal rights during the struggle between the North and South. The campaign for woman's rights gathered more momentum after the war, but it would take several decades before women gained the right to vote and participate in government.

*Notes: "1852 Pennsylvania Woman's Rights Convention" from the National American Woman Suffrage Association Collection, 1848–1921; news clippings and miscellaneous data from CCHS.*

## Will Downing Goes to War

Will Downing was described by friends as carefree and impulsive, always looking for a good time. He was five-feet six-inches tall, with blond hair and intense blue eyes. A relative called him the "black sheep" of the family because he did as he pleased without much thought for the consequences. By June 1862, Will had finally completed his apprenticeship with William Thomas at the West Whiteland Mill. The Civil War had begun the year before. Now he wanted to join his younger brother, Joe. In August 1861, Joe and their cousin, Ben, had enlisted in the Forty-ninth Regiment, Pennsylvania Volunteers. They were stationed at Camp Griffin near Washington, D.C. Will could have gone to West Chester to enlist, but he wanted to be in the same company as his brother, so he walked all the way to Washington to muster in with the Forty-ninth Regiment; 175 miles was a long walk for Will, but he did not mind. He met up with Joe and settled into camp life, but all they seemed to do was camp and march. Will was ready to fight.

During the summer of 1862, the regiment moved down to Harrison's Landing in lower Virginia, but in September it marched north, hoping to prevent the enemy from reaching Pennsylvania. The Confederate

# The Nineteenth Century

This photograph of Will Downing was probably taken during a visit home in 1863. *Constance Happersett of the Uwchlan Township Historical Commission.*

army did not get into Pennsylvania in 1862 because it was stopped along Antietam Creek near Sharpsburg, Maryland. The Union forces protected Pennsylvania, but at an enormous cost. More than twenty-two thousand casualties occurred in a single day. Will was glad to finally see some action, but he was seriously wounded at the Battle of Antietam and spent more than one month at Mount Pleasant Hospital in Washington, D.C. During his hospital stay, he wrote to his sister, Sarah, saying that he had come to believe that war was awful but that he would do his part as long as it lasted. In fact, he was anxious to get back to the regiment. He knew that he was not alone in his thoughts about the war and the army. Many soldiers admitted that if they could they would go home and stay there.

The Union army returned to Virginia and was defeated at the Battle of Fredericksburg in December. The soldiers settled into a winter camp near White Oak Church. Will hated the encampment, located in a wild terrain of scrub pine trees and bushes. They camped for days with nothing to do for long periods of time. One time, Will wandered from the encampment and got lost in the brambles and undergrowth. His brother Joe was a first sergeant and was sent back to Pennsylvania for recruiting duties. Will was lonely and itching to fight. He was granted a furlough in June. He enjoyed the trip home, attending a dance and a friend's wedding. He joked that the bride was already armed with her rolling pin. When his furlough ended, Will managed to make his way back to central Virginia just in time to march back to Pennsylvania for the Battle of Gettysburg in July.

In September 1863, while camped near Warrenton, Virginia, Will's impulsiveness got him into trouble. While on guard duty, he decided to take a look at the supply tent. He found a coat that fit him just right, so he put it on and returned to his post, only to find the company commander waiting for him. He faced a court-martial on three charges: conduct prejudicial to good order and military discipline for stealing a coat, violation of the Twenty-first Article of War for absenting himself from the company without permission and violation of the Forty-sixth Article of War for leaving his post. Fortunately for Will, he was found innocent of the more serious charges but guilty of stealing the coat. His rank was reduced to private, and his pay was reduced by five dollars per month for ten months.

During the long times between battles, men were sometimes sent out to skirmish with the enemy. Skirmishes were usually minor encounters, small in numbers of troops and in the intensity of the fighting. In November, while out on skirmishing duties, Will was captured by the enemy and sent to Libby Prison in Richmond. Five weeks later, he became ill and was sent to a nearby hospital for contagious diseases. He was there for one month. On January 22, 1864, Will escaped from the hospital and walked back to his regiment camped at Brandy Station. By this time, Joe was a first lieutenant and Will was still a private.

Some of the Civil War's worst fighting occurred in May 1864 in central Virginia. A few miles west of Fredericksburg, the Wilderness was a tangle of bramble and undergrowth in which soldiers lost their way.

# The Nineteenth Century

Gunfire started forest fires that left soldiers on both sides burned beyond identification. The Forty-ninth Regiment suffered through heavy fighting in the Wilderness. The regiment losses included eleven killed and twenty-three wounded. Joe and Will survived the Wilderness without injury, but the worst was yet to come.

After the Wilderness, the army moved a few miles south to Spotsylvania Courthouse. While the two armies were forming their defenses, Colonel Emory Upton pressed his superiors for the Union army to be more aggressive. He proposed a daring attack to break through the Rebel lines. Twelve Regiments were selected to participate in the charge. Will Downing was thrilled to learn that the Forty-ninth Regiment would be included. This charge was just the kind of bold maneuver that Will preferred. The tightly formed regiments would march silently through the woods and await orders. When the call was made, six thousand men charged the Rebel works. In less than ten minutes, Union soldiers had broken through the lines, capturing more than one thousand prisoners and controlling the Confederate artillery.

Everything happened so fast that there was no time to reload weapons. Soldiers used bayonets, rifle butts and fists. The Union reinforcements who were supposed to back up the charge were engaged about a half mile away. Confederate defenses counterattacked, driving Union forces back. The casualties for Upton's charge came to 1,000 killed, wounded or taken prisoner. The Forty-ninth Regiment was caught in the open field and was one of the hardest hit and the last to leave. Of 474 soldiers on the field that day, 67 were killed, 171 were wounded and 8 were taken prisoner. The heavy man-to-man fighting continued for several days, leaving the dead and wounded unattended on the field. Lieutenant Joseph Downing could not find his brother, Will, and reported him missing. Joe was severely wounded in his hand (and never regained the use of it). After several days, Will was found dead from a gunshot wound. He was twenty-two years old. He is buried in one of the many mass graves at Fredericksburg National Cemetery.

*Notes: Happersett, Gaines and Brody,* Dear Sister.

## Civil War Nurse Lil Zook

When the Civil War began in 1861, Elizabeth "Lil" Zook was a thirty-one-year-old spinster still living with her parents on the family farm in West Whiteland. Despite concerns from her family, Lil decided to help the war effort by becoming a nurse. In 1862, she traveled by train to Washington, D.C., and found employment at a hospital in Georgetown.

At the time of the Civil War, hospitals were staffed by nurses hired by the Sanitary Commission, an independent service organization similar to today's Red Cross. It aided the Union by furnishing equipment and supplies to help maintain cleanliness. Once the war began, the commission took on the responsibility for staffing hospitals with nurses. As the wounded

Elizabeth "Lil" Zook worked as a nurse during the Civil War. *Library of Congress Prints and Photographs Collection.*

increased in number, the need for nurses became quite challenging. The Sanitary Commission nurses were under the direction of Dorothea Dix, a well-known advocate for better treatment of prisoners and mental patients. She agreed to lend her expertise to aid hospitals treating wounded soldiers.

When she first arrived, Lil was assigned to night duty. The night shifts were relatively easy because most patients were asleep. Occasionally, a new patient was brought to the ward at night, and Lil would bathe the soldier, get him settled into a cot, check the conditions of his dressing and watch carefully for any signs of change in his condition. Once Lil adjusted to working at night, she developed a routine. She slept from early morning until about noon. Then she rose, ate a light meal and took care of personal chores. In the middle of the afternoon, she visited the ward to see if any of the soldiers needed her help with sewing or writing letters. She supplied paper, pen and ink and, in many cases, wrote the letters. She could often be found sitting near a patient with needle and thread in hand, mending a uniform while she talked with the soldier. One time, the soldiers in the ward pooled their funds to buy Lil a present, a gold pencil case with a pen on a chain.

In a letter she sent home, Lil expressed satisfaction with her work. She felt that she was making an important contribution to the war effort and that the doctors and soldiers seemed to like and appreciate her for all she did to make their lives better. She mentioned at times having difficulties with Miss Dix, who did not like her, but Lil was still happy to be of service. She voiced her concerns about when the war might end, and she mentioned that many soldiers had no interest in fighting, saying that they hoped to go home and that if they could, they would not enlist again.

One of Lil's greatest fears was the spread of disease. Infections were common in the hospitals, and infectious diseases could quickly become epidemics. In 1863, the hospital suffered through a diphtheria epidemic that lasted several weeks and caused many deaths. Some of the men were barely alive when they arrived from the front, so they had no strength to survive the severe symptoms of this dreaded disease. Lil worried about getting sick herself, but her concerns were also focused on the shortage of nurses caused by such epidemics.

In 1864, Lil was given leave for a home visit. She enjoyed visiting her family but looked forward to returning to her nursing duties, this time at

Lil Zook later worked and died at Hampton Hospital in Virginia. *Library of Congress Prints and Photographs Collection.*

Hampton Hospital in Virginia. She was there until the war ended in the spring of 1865. She could have gone home then, but Lil chose to stay. There were still many soldiers who were too sick to move. Lil decided to stay as long as any soldiers were at Hampton. In a June 1865 letter, she explained to her brother, Jacob, that some of the soldiers had been in her care for nearly a year. Although most of the matrons (nurses) were leaving and she hoped that the hospital would soon close, she would stay until the end.

With the war over, Lil was able to see some of the Virginia countryside. She was shocked by what she saw. Farms were destroyed. Both people and livestock were extraordinarily thin. Food was scarce, but farmers were trying to begin again, planting crops in fields once used for battles. Lil decided that she had done enough nursing. Once the hospital closed, she looked forward to returning home. Perhaps she would become a teacher. In late summer, Lil caught bilious fever from one of her patients. On September 4, 1865,

## The Nineteenth Century

Elizabeth "Lil" Zook died at Hampton Hospital. Her parents were able to arrange to have her body returned home by train, and she was buried at the Downingtown Quaker Meeting cemetery.

*Notes: Brody,* Constant Struggles, *36–37; manuscript collection from CCHS.*

# The Great Tornado

Married in September 1876, Howard and Sallie Widdoes lived in a rented house on Davis Woodward's farm on the road from Ercildoun to Glen Rose. Howard was building a barn in Unionville, so he stayed there during the week, leaving Sallie alone at night for the first time in her life. On Friday night, June 29, Sallie dreamed that hundreds of people, mostly colored, passed by on the road near her house. Howard returned on Saturday, and on Sunday morning he was outside catching up on the chores. Ben Yoeman joined them for Sunday dinner, praising the beans Sallie had just picked from the garden. They saw storm clouds gathering as they finished their meal. Ben ran to the meadow to retrieve the colt, while Howard ran to secure the barn doors. Ben remarked that the strange "dun-colored cloud" reminded him of the cyclones out west.

Sallie gathered her goslings and chicks but had difficulty closing the shed door. The wind was so strong that she ran to the kitchen door to grab her bonnet. Just as the men shouted at her to get away from the house, she saw the house next door lifted off the ground, spun around and thrown down on its roof. She ran toward her husband, and the men lifted her over a fence; they all crouched in a ditch and watched in awe as a tornado spun through their yard. They could see trees in the funnel with apples hanging and potato plants with the potatoes still clinging to the roots. Suddenly, the air was full of feathers, and Sallie later discovered her chickens completely bald but alive and unharmed. Arising once the storm had passed, they saw smoke coming from the overturned house next door, so they rushed to help. They pulled the colored children out, seeing that the girl's legs were badly burned. There was no sign of their mother, Mary Hopkins. Another neighbor, Diane Ringold, joined them and comforted the children while the men went to find the

mother, whom the children said had gone upstairs to close the windows. She was found dead in the rubble. For days after the storm, Sallie saw people, both colored and white, passing by her house, just as she had dreamed the Friday before. Once her husband returned to work, Sallie went to visit family in Marshallton. She just could not stay alone in her home, surrounded by the destruction.

Tornados are rare in southeastern Pennsylvania, and the few that do occur usually cause minimal damage. On July 1, 1877, a tornado moved through western Chester County, causing considerable destruction. Sunday began as a typical hot summer day, with temperatures rising to a sultry ninety-two degrees. In the early afternoon, the skies turned dark in the west, signaling that a storm was coming. It was not raining, but the wind picked up, blowing dust across the farmlands near Ercildoun. The first sighting of a funnel cloud was one mile east of Gap, in eastern Lancaster County, on the farm of Joseph Pownell. He watched as the funnel passed over a stream and sucked up the water, leaving the streambed dry. The tornado roared through his cornfields and destroyed his apple orchard before heading toward Sadsbury Quaker Meeting. The first building hit and leveled to the ground was Robert Johnson's tenant house on Elwood Pownell's farm. Pownell's wagon shed and carriage house were destroyed, while his barn remained intact but was lifted one foot off its foundation.

As the tornado came to full strength, its landfall was one hundred to three hundred feet wide. Objects could clearly be seen in the funnel cloud—trees, wagon wheels, wood siding—all spinning within and thrown off in an unpredictable fashion, causing more damage. No rain or hail accompanied the tornado itself, but they were experienced a few miles away. The tornado moved in a southeasterly direction for most of the path, but twice it veered off to the north and east. Thomas Bonsall's farm, about a mile north of Christiana, sustained the loss of the barn roof and damage to his orchard and fencing, but the funnel entirely missed his house. Nearby, the storm demolished Frank Pearson's barn, outbuildings and trees. The stone dwelling shook with the wind but remained intact.

The funnel then headed up a wooded hill a few miles from Parksburg. Several small homes and trees were twisted off the ground and scattered, leaving several residents of modest means with nothing. For a few weeks

after the storm, a collection was taken to help the poorest people. Grants of $100 to $400 were provided to the most needy.

The village of Ercildoun was the hardest hit. The tornado destroyed several small houses before it hit the grand four-story building that housed the Ercildoun Seminary, an admired boarding school for young women. The school's director, Richard Darlington, lost his residence, a new house under construction and much of the large school building. His estimated loss was $9,500, by far the greatest loss of all the victims. The storm continued east toward Marshallton, descending closer to land and widening its landfall to three hundred feet. The properties of Richard Bailey and Joseph Marshall sustained considerable damage before the funnel cloud began to dissolve, spinning to a higher elevation and causing the remaining debris to fall over fields about a mile west of Marshallton.

As word of the disaster spread, visitors to Ercildoun began arriving by early Sunday evening. Some came to help or look for a relative, but most were merely curious. Reporters, photographers and artists came to work. For about three weeks, the curious came and gazed with astonishment at the scenes of destruction, tying up roads with their carriages and wagons. It was

In 1877, a tornado destroyed much of the Ercildoun Boarding School. *From* A Full Description of the Great Tornado in Chester County, Pennsylvania *by Richard Darlington Jr.*

The building that once housed the Ercildoun Boarding School was rebuilt with two stories instead of four. *Photograph by Jack Stapleton.*

estimated that five thousand visitors passed through Ercildoun on Sunday, July 8. The tornado blazed a path of destruction twenty-two miles long and caused one death, three serious injuries, two hundred minor injuries and $40,000 in damage. As Richard Darlington said, it was a fantastic display of the wild fury of the elements.

*Notes: Darlington,* Full Description of the Great Tornado; *news clippings and miscellaneous data from CCHS.*

## THE PICKERING VALLEY TRAIN WRECK

The Pickering Valley Railroad was organized in 1868 as a commercial rail extension for the benefit of the area millers and dairy farmers. With construction completed in the summer, the first train operated on August 26,

# The Nineteenth Century

1871. There were eight stations, two to three miles apart, from Byers (near Lionville and Eagle) to Phoenixville, connecting to trains on the Reading-to-Philadelphia line. The Philadelphia and Reading Company leased the passenger contracts from the Pickering Valley Company. Trains ran three times per day each way. In its six years of operation, most of the business was delivering milk tanks from local dairy farmers to the depot in Phoenixville. Regular passengers included several students traveling to and from high school in Phoenixville. It was rare that there were more than ten passengers on a train.

On Thursday, October 4, 1877, the passenger cars were full early in the day, taking family members to a reunion at Pennypacker Mill near Schwenksville in Montgomery County. The day was special; it was the 100th anniversary of the Battle of Germantown in the American Revolution. The Continental army had encamped at the mill before and after the battle. Several hundred attended the reunion, despite severe rainstorms throughout the day. Quite a few Chester County family members rode a train to Phoenixville to return home in the late afternoon. The last Pickering Valley train awaited in the station for those returning to Kimberton, Chester Springs, Lionville and Eagle.

The rains that day had been the heaviest ever recorded in that part of Chester County—five inches in less than twenty-four hours, with two inches between 5:00 p.m. and 6:00 p.m. The tracks just north of Kimberton Station crossed a man-made embankment about one hundred feet long and fifty feet wide, built when the track was originally laid seven years earlier. The train had made the outgoing run to Phoenixville shortly after 4:00 p.m., traveling along the tracks through torrential rains without any problems.

The Pickering three-car train with 120 people on board left Phoenixville shortly after 6:00 p.m., passed the French Creek Station and approached the Kimberton Station. The heavy rains continued. As was common on the Pickering line, the engine and the coal car were reversed on the return trip. The engineer could only see the tracks by the one headlight on the coal car. The tracks were clearly visible, though, on the dark rainy night. However, the engineer could not see that, sometime between the outbound and return runs, the entire embankment had been washed away into the raging French Creek fifty feet below, so there was nothing supporting the rails. The train hit

Citizens from Phoenixville and the surrounding farms rushed to rescue victims of the Pickering Valley train wreck. *Historical Society of Phoenixville, Pennsylvania.*

the open tracks and plunged fifty feet down into the wash—first the coal car and then the engine, the gentlemen's car and the ladies' car, which wedged into the rear of the first passenger car. The milk car in the rear of the train stayed up on the tracks, held there by resting on the second passenger car. There had never been such a disaster in the Phoenixville area.

The engineer, J. Frank Kenney, and fireman, George Griffith, were killed instantly. The conductor, Charles Golden, extricated himself from the wreckage and ran back toward Phoenixville to get help. Rear brakeman Benjamin Major in the rear car was thrown into the milk tanks but was not seriously injured. He escaped and stayed to help remove the injured. The train dispatcher, John Haviland, arranged for a rescue train to come from Reading. Those on neighboring farms heard the terrible sounds of the crash and the screams of the injured. The fire bells and school bells were rung to alert the citizens to the disaster and rally rescue teams, who worked through the night in the pouring rain to remove the injured and the bodies of those who died in the crash. Some of the most severely injured were caught in the wreck for hours.

# The Nineteenth Century

The injured were taken on the relief train to the Phoenixville Masonic Hall, which had been turned into both a hospital and morgue. Thousands showed up to help. Runners were sent out to notify area doctors. In addition to the engineer and fireman, five others died when the train plunged down into the ravine: Nathan Pennypacker; William Hallman; his wife, Sallie Hallman; Isaac Tustin; and his son, Jones Tustin. Brakeman Michael Corbett was pinned between the bumpers of the two cars, and his legs were crushed. He was not released until five o'clock Friday morning. He died the next day. Abraham Pennypacker and Joseph Tustin sustained serious injuries from which they never recovered, dying several weeks after the accident. Close to one hundred people suffered a range of injuries, but remarkably, a few climbed out of the wreck unscathed. Herbert Hartman, Orlando March and J.B. Clevenstine were thirteen-year-old boys who regularly rode the train to and from school. Herbert and Orlando were miraculously thrown uninjured from the train onto the embankment. They ran to a local farm to get help and then returned to search for their friend. J.B. had been thrown toward the end of the car and lay there dazed, with a broken arm. Since the other rescuers were busy with the more seriously wounded, Herbert and Orlando worked to free J.B. and then carried him all the way to his home in Kimberton.

On Friday, County Coroner William Rambo and Deputy Coroner S. Hunter called for an inquest and empanelled a jury to investigate the deaths of the first seven. The jury began its investigation at the scene of the disaster and then took testimony of the many witnesses. Some questioned the safety of running the engine backward, stating that with the engine in front the larger headlight might have given the engineer enough warning of the impending disaster. Others pointed out that the fires created by the impact were small and easily extinguished, which would not have been the case if the tender had been next to the passenger cars.

In a report promptly released on Monday, October 8, the jury found that the embankment at the place of rupture had been considered safe by the railroad companies and also by the employees and the general public. The jury found that the order of the rail cars was a violation of company policy, even though it had been done that way frequently in the past. The greatest fault was directed at the railroad companies for installing iron

grills on all of the windows in the passenger cars, which greatly slowed the rescue process. Had the windows been free of obstructions, the passengers would have been better able to escape. The jury found both railroad companies responsible, but the obvious cause of the accident was the extreme weather, which caused the unanticipated collapse of an otherwise safely built embankment. The railroad company had workers cleaning up and fixing the embankment by Saturday. In three days, the crew installed steel columns to bridge the gully where the tracks had been undermined by the storm, and the railroad was back in operation. By Tuesday, October 9, the milk runs were once again the primary feature of the Pickering Valley Railroad. Rescue, investigation and cleanup were executed rapidly, but the memories of the terrible disaster haunted the citizens of Phoenixville and the surrounding villages for many years.

*Notes: Miscellaneous data from the Historical Society of Phoenixville; news clippings from CCHS.*

# Buffalo Bill in Chester County

William Frederick Cody, better known as "Buffalo Bill," was born and raised in the West. Indian hunter, guide, Pony Express rider and buffalo hunter, he is perhaps best remembered for his Wild West Shows. Buffalo Bill has several connections to Chester County, Pennsylvania. His mother was born in Germantown, Philadelphia. Her sister married West Chester resident General Henry Guss. In 1872, Bill visited his uncle in West Chester for the first time. The next year, before his first show tour, Bill Cody moved to West Chester with his wife and children. They lived on Washington Street between Walnut and Matlack Streets for nearly two years while Bill traveled with his show.

Cody's first show featured the Scouts of the Plains. Buffalo Bill, Texas Jack and Wild Bill Hickok, plus a corps of Indians, performed in a play titled *Buffalo Bill, King of the Border Men.* They rehearsed at Horticultural Hall in West Chester in preparation for a tour that included Philadelphia, New York and Baltimore. Their one-night show at Horticultural Hall on September 4,

# The Nineteenth Century

Buffalo Bill Cody often visited Chester County. *Charles "Pete" Hayes Jr.*

1873, may have been the first show of its kind in the East. The family moved to Nebraska in 1874, but Bill continued to visit West Chester whenever he was in the region. To lighten the load before the move, the Cody family disposed of many household items at a huge sale held at Horticultural Hall. Many local citizens attended the sale in hopes of purchasing something as a souvenir from the famous Buffalo Bill.

After the family returned to the West, Buffalo Bill raised cattle and spent several summers serving as a guide for European tourists and hunters. During winters, he traveled with his troupe, performing dramatic stories of the Old West. His annual visits to West Chester were eagerly anticipated by local residents.

Charles Trego, born in Honey Brook in 1855, was an excellent horseback rider and sharpshooter. In 1885, he went west and obtained a job working for Bill Cody, tending the horses on the Cody ranch. In that same year, Buffalo Bill created an exciting new show called Buffalo Bill's Wild West. The earlier shows were simply plays depicting historical events about settling the West. This new show was different—a combination of dramatic skits and circus acts. It was bigger and more exciting than any of his previous endeavors. Charlie Trego traveled with the show, caring for the animals and occasionally performing. The Wild West Show was a complicated endeavor, requiring complex travel arrangements and large arenas for performances. Buffalo Bill's Wild West Show was presented in facilities like the Madison Square Garden in New York. (The original Madison Square Garden opened in 1876.)

In 1887, Buffalo Bill's Wild West Show sailed across the Atlantic Ocean for a grand European tour. In England, in celebration of Queen Victoria's Jubilee, a stadium was built to hold twenty thousand spectators. The queen saw the show, and by royal command, a special performance of Buffalo Bill's Wild West Show was given for the three thousand diplomats invited to the Jubilee. The Wild West Shows continued to please audiences for many years to come. The last European tour took place in 1903.

Charlie Trego worked for Buffalo Bill for thirteen years. In 1897, he married a widow from Chester County, Carrie Ash Hayes. He took her west to the Cody ranch, but she was unhappy there, so Charlie stopped working for Cody and returned to Chester County. By that time, Bill Cody had begun to bring animals east to Chester County in the fall to train them for shows. They were sent by train and spent three to six months at local farms in West Brandywine, Caln and Oxford. J. Caldwell Moore, Charles Ash and others cared for show animals for Bill Cody. When Charlie and Carrie Trego returned to Chester County, he also tended to Cody's animals, first in Wagontown and later in East Brandywine Township, near Guthriesville. From 1895 to 1913, when the Wild West Show held its last American tour, many horses were brought to Chester County to be trained for performance.

As the years passed, Buffalo Bill's show became more exotic, featuring not only horses and buffalo but sometimes elephants and camels as well. Each year, as many as two hundred horses, a dozen buffalo and occasionally

# The Nineteenth Century

Horses, buffalo and camels from Buffalo Bill's Wild West Show spent their off season on Charles Trego's farm in East Brandywine Township. *Charles "Pete" Hayes Jr.*

camels were housed on local farms. On Sundays, residents often visited the farms to see the animals and hopefully catch a glimpse of Buffalo Bill on one of his infrequent visits. Local citizens watched for the show trains' arrivals in Coatesville. Many gathered to see the animals loaded onto the trains to go on tour or return to the West. When Buffalo Bill's Wild West Show finally closed, some of the show items stored locally were auctioned off to the delight of longtime fans.

Charlie Trego never sought the fame and status of Buffalo Bill, but his skills and physique were admired by a famous artist. In 1907, after seeing Charlie perform in a show, sculptor Frederick Remmington engaged Charlie as a model for his large statue of a cowboy on horseback that was commissioned by the Fairmount Park Art Association. The Remington sculpture, *The Cowboy*, can be seen along Kelly Drive near the Girard Avenue Bridge in Philadelphia.

*Notes: News clippings and miscellaneous data from CCHS; information from the family of Charles Trego—Jack Stapleton and Pete Hayes.*

# Part III
# The Twentieth Century

## The Lynching of Zachariah Walker

Zachariah Walker had come north from rural Virginia to Coatesville, Pennsylvania, to work at a steel mill. He was an unskilled laborer at Worth Brothers Steel Company. He lived about one mile south of the borough in East Fallowfield Township. Most steelworkers were paid on Friday, and many spent the weekend drinking away their earnings. On Saturday, August 11, 1911, Zachariah Walker drank heavily with a friend. Late that night, on his way home, he tried to rob two Polish immigrants, threatening them with a gun, which he shot into the air. They got scared and ran toward town. Edgar Rice was a former policeman who worked as a security guard for Worth Brothers. Edgar heard the shots while making his rounds at the steel plant. He went to investigate and found Zachariah near the First Avenue Bridge over Brandywine Creek, very drunk and still waving his gun. Edgar questioned him about the attempted robbery and tried to take him back to town to be arrested. Only Zachariah Walker could say exactly what happened next, but Edgar Rice was shot twice. Rice staggered back down the road, collapsing and dying outside a neighborhood grocery store.

Although drunk, Walker knew that he was in trouble. He fled south of town and hid in a barn. In no time at all, word of Rice's murder spread through the borough. The police chief, Charles Umsted, gathered his officers to search for Walker. They hunted through the rainy night without success. On Sunday afternoon, many groups of police, volunteer firemen and local citizens hunted for Walker, who had fled the barn and was hiding in a tree. He was now sober enough to realize what he had done. He tried to kill himself by shooting his head, only to put the bullet into his jaw. Volunteer firemen heard the shot and arrived in time to see Walker fall out of the tree. He was taken to the police station and interrogated by Chief Umsted. A large crowd had gathered outside, and the anger over Rice's death had grown. Walker really needed medical attention, so Chief Umsted and Officer Stanley Howe took him to Coatesville Hospital. Surgery was performed to remove the bullet from his jaw. He was put in a hospital room, restrained with a straightjacket and shackled to the iron bedpost. Chester County district attorney Robert Gawthrop joined the chief for further interrogation. Walker admitted shooting Rice but insisted that it was self-defense.

With Officer Howe left on guard, Chief Umsted and District Attorney Gawthrop left the hospital. In Coatesville, crowds were gathering on the streets and at the fire companies. Chief Umsted talked to a crowd at Brandywine Fire Company, regaling them with the story of Walker's arrest and confession. Edgar Rice had been well loved by the community, a solid citizen with a wife and five sons. The mood of the people changed from somber to angry. Small groups of people began walking toward the hospital. The fire company crowd grew larger. Someone suggested "lynching the nigger!"

At about eight o'clock in the evening, the angry mob left the firehouse and moved quickly toward the hospital. People leaving evening church services joined the throng. At least two thousand people, including women and children, soon stood outside the hospital's front doors. Miss Lena Townsend, superintendent of the hospital, was frightened by the gathering mob. She called Chief Umsted for help, but he refused to come. About fifteen young men broke through the front doors and searched the hospital for Walker. Officer Howe was guarding Walker's room but was easily brushed aside by the mob. The men demanded the key to unlock the shackles, but Howe

# The Twentieth Century

Zachariah Walker, arrested for the murder of Edgar Rice, was taken from Coatesville Hospital by an angry mob. Coatesville Hospital, 1901, postcard. *Chester County Historical Society, West Chester, Pennsylvania.*

didn't have it, so they tore the bed apart and dragged Walker outside, his leg still attached to the bedpost. Officer Howe tried unsuccessfully to reach Chief Umsted by telephone.

The men dragged Walker about half a mile out Strode Avenue, beyond the borough limits. Many tried to hit or throw things at Walker, but the leaders did not want him seriously injured; they wanted him to know and understand the pain of death. Walker was dragged to a field on a Newlinville farm, not far from where Rice had been shot. They gathered straw and fence posts to build a pyre. Once the bonfire was lit and blazing, they threw Zachariah Walker on the fire. Walker pleaded with the mob that he had shot Rice in self-defense, saying, "Don't give me no crooked death because I'm not white." Then he struggled to get off the fire. Three times he stumbled off, only to be dragged or pushed back. By this time, it was reported that as many as five thousand stood and watched the spectacle. No one tried to stop the lynching. Many waited through the night, watching as the fire burned itself out. Most of those in attendance thought that justice had been served. Later, many expressed dismay that newspapers all over the country condemned the lynching. They honestly believed that no wrong had been

done. Outsiders considered the lynching a crime against humanity. Even southern newspapers denounced the event, pleased to remind the public that the event occurred in the North. On August 17, six thousand attended the funeral of Edgar Rice at the Hepzibah Baptist Church in Youngsburg.

County authorities investigated, with little cooperation from Chief Umsted. Less than three weeks after the lynching, after interviewing 160 witnesses, the grand jury indicted 8 men for the murder. A few others were arrested but later released. Chief Umsted and Officer Howe were charged with involuntary manslaughter for doing nothing to stop the mob. The citizens of Coatesville who were not charged refused to identify anyone and tried to protect others in what the grand jury called a "conspiracy of silence." District Attorney Gawthrop (who had witnessed the original interrogation by Umsted) was appalled by the lynching in Coatesville. He said, "Men who took part were more cowardly than wolves and more devilish than fiends when they tortured the man as they did."

The eight men indicted for murder were Joseph Schofield, Norman Price, George Stoll, Chester Bostic, William Gilbert, Albert Berry, Joseph Swartz and Oscar Lamping. Coatesville residents went into the streets to protest the actions of the grand jury and again when Chief Umsted and Officer Howe were taken into custody. They returned to the streets each time a defendant was released on bail, cheering the men as heroes. Gawthrop arranged for quick prosecution of those charged. The jury selection included no one from Coatesville. Judge William Butler began the trial of Joseph Swartz on October 3. Swartz was found not guilty on October 5. The trial of George Stoll began on October 6 and ended the next day with an acquittal. Joseph Schofield's trial began on October 9 and ended on October 11 with an acquittal. Albert Berry and William Gilbert were found not guilty on October 12. The district attorney stopped the process and released Norman Price, who had turned state's evidence. It appeared that no one was going to be found guilty of the murder of Zachariah Walker. The next trials were scheduled for January 1912, but they were postponed again when seven more men were indicted.

During the months following the first trials, the Commonwealth of Pennsylvania and the county tried without success to change the venue for future trials. The others who had been indicted, including Chief Umsted

and Officer Howe, waited to be brought to trial. Further investigations were completed by the state authorities. On May 3, 1912, District Attorney Gawthrop asked that all charges against remaining defendants be dropped. The jury quickly returned not guilty verdicts against all of the accused. Pennsylvania's deputy attorney general, who was assisting in the prosecutions, said, "The responsibility for the failure to enforce the law in these cases, and for the miscarriages of justice that have occurred must necessarily rest with the juries." Judge Butler also expressed his dismay: "For some reason that I am entirely unable to understand, a sentiment in this county is utterly opposed to the conviction of anybody who took part in this horrible affair."

*Notes: Zigler, "Community on Trial," 245–70; news clippings and miscellaneous data from CCHS; Downey and Hyser,* No Crooked Death.

## The Justice Bell Tours for Suffrage

In 1915, many American women were actively seeking the right to vote. Marches and campaigns had reached national levels in the few years before the 1915 efforts. President Woodrow Wilson had tried to deflect the women by suggesting that suffrage was a states' rights issue, since many western states had already granted voting rights to women. Some prominent women led the way in Chester County, including the county's first female attorney, Isabel Darlington of West Chester; socialite Gertrude Clemson Smith of Strafford; Quaker leader Rebecca Pennock of Kennett Square; and dairy farmer Martha Thomas of Whitford.

In April, Katherine Rauschenberger of Strafford funded the forging of a bell modeled after the Liberty Bell. The bell was anchored to a specially built truck, and the clapper was chained so that it could not ring. The sponsors stated that the bell would remain silent until women won the right to vote; only then would the Justice Bell ring. The campaign in Pennsylvania was important because the referendum on the ballot in November would decide the women's vote for years to come. The state legislature agreed to consider the referendum on the condition that if it failed it would not be considered for another five years. Other states had similar provisions.

Funded by Katherine Rauschenberger of Chester County, the Justice Bell toured Pennsylvania in support of woman's suffrage. *Library of Congress Prints and Photographs Collection.*

Beginning in June, the Justice (or Suffrage) Bell toured every county in Pennsylvania. In all sixty-seven counties, women organized parades and lectures in support of woman's suffrage. Nationally known speakers traveled with the bell, urging men to vote for suffrage. On October 22, the bell was welcomed to Philadelphia by more than five thousand supporters.

During the last week of October, the bell toured throughout Chester County, beginning in the north, moving south to the western towns and finishing in the county seat, West Chester, where the Woman's Suffrage Association was headquartered. Many villages and towns planned parades and celebrations, including participation by bands, veterans and schoolchildren. Opponents also gathered to see the bell as it passed through towns such as Coatesville, Parksburg West Grove, Kennett Square and Avondale. Two older women were featured guests in Parksburg. Susanna Brinton and her sister, Mary Brinton Hopkins, spoke of their efforts for woman's rights. They had been activists for more than sixty years and had attended the 1852 convention in West Chester.

# The Twentieth Century

West Chester was the final stop of the five-thousand-mile journey through the state. The truck carrying the bell stopped in front of the courthouse at 5:00 p.m. on Saturday, October 30. According to the local newspaper, the streets were full. One of the largest and most attentive audiences in the history of the town stood to look and listen while speaker after speaker related the story of the campaign and predicted that women would one day vote with their husbands and brothers.

The bell's owner, Katherine Rauschenberger, said, "It is here that we rest our case. The bell comes back to its own home after making a complete tour of the state, standing in front of Independence Hall only a few yards from the Liberty Bell. This is the home of the bell because in June 1852, the first woman suffrage meeting in Pennsylvania was held in West Chester." Ninety-seven-year-old Dr. Jesse Green praised the women and their efforts. He remembered the first convention because he was one of its sponsors.

West Chester's celebration ended the day before election day. The women and the men who supported them had successfully lobbied the legislature to put forward the proposed amendment to the state constitution, which stated:

> *Every Citizen, male or female, of twenty-one years of age, possessing the following qualifications, shall be entitled to vote at all elections, subject, however, to such laws requiring and regulating the registration of electors the General Assembly may enact.*

The referendum was defeated by a statewide vote of 441,034 against and 385,348 in favor. Chester County's vote was 7,429 in favor and 6,035 against. Chester County was the only county in southeastern Pennsylvania to vote in favor of woman's suffrage. The women here and in other states realized that they would have to change their approach. They had devoted years to earning the vote state by state, as President Wilson had suggested. Now the campaign returned to national efforts.

The Nineteenth Amendment to the United States Constitution was proposed on June 15, 1919, and finally passed on August 26, 1920, seventy-two years after the first woman's rights convention. On September 20, the Justice Bell was brought to Independence Hall, where the clapper was unchained and rung in celebration. The National Suffrage Association

became the League of Women Voters. One of Chester County's suffragettes, Martha Thomas, was elected to the state legislature in 1922, Pennsylvania's first female representative. The Justice Bell was retired and for years has been housed at the Memorial Chapel at Valley Forge National Historic Park.

*Notes: News clippings and miscellaneous data from CCHS;* Philadelphia Inquirer *from Chester County Library Database; National American Woman Suffrage Association Collection, 1848–1921.*

## TUSKEGEE AIRMEN IN CHESTER COUNTY

Born in December 1920, Andrew L. Smith was the eldest son of Carl and Amelia Winters Smith. He had three brothers and one sister. Andrew graduated from Coatesville High School in 1939. Although educational opportunities for blacks were limited, he studied at Berean Institute of Philadelphia and at the Utility Engineer Institute of Chicago. Like thousands of young men, Andrew enlisted after the Japanese attacked Pearl Harbor in December 1941. He received basic training at Fort Meade, south of Baltimore, Maryland. Fort Meade served as a training center for 3.5 million men during World War II. After basic training, Andrew was assigned to Camp Crowder for advanced training in mechanics. Opened in 1941, Camp Crowder in Missouri was one of the few military bases that trained both white and black units in the segregated army. Women also received training there for the Women's Army Corps. After successfully completing the mechanics training, Andrew was sent to flight school at Tuskegee, Alabama.

For years, black men had been trying to obtain training as pilots, but the United States government was determined to continue segregation and keep black soldiers in unskilled positions such as kitchen help, construction jobs and truck driving. In 1939, Congress passed a law allowing civilian aviation schools to train pilots for the military. After Great Britain and France declared war on Germany, Congress approved more training sites for the Civilian Training Program, including Tuskegee Institute. As a pilot training facility, Tuskegee was still segregated. The training staff were civilians led by

# The Twentieth Century

Chester County was well represented by the Tuskegee Airmen. *Library of Congress Prints and Photographs Collection.*

Charles Anderson, the first African American to earn a private pilot's license in the United States.

Andrew Smith was part of the Ninety-ninth Squadron led by Benjamin O. Davis Jr., who in 1936 was the first black person to graduate from West Point. Andrew had faced discrimination at home in Coatesville but was unprepared for the challenge of living in the Jim Crow South. Because all of the trainees were black, the challenges of the strenuous training program were easier for the men to deal with than was the Alabama community outside the training facility. During the war, Tuskegee trained 992 men

as pilots. In addition, nearly 10,000 black soldiers were trained in support positions—navigators, mechanics and technicians. By the end of 1942, the Ninety-ninth Squadron was more than ready to join the war in Europe, but army prejudice prevented its deployment until April 1943.

At first, the well-trained black pilots were assigned to support operations. They rarely encountered enemy planes but instead were assigned to destroy fuel stations, ammunition depots and supply routes. In October 1943, the squadron was transferred to the Seventy-ninth Fighter Group, whose commander treated the black pilots as equals. They flew in formation with whites and were sent on the same missions. In 1944, the highest admiration of the public went to the men shooting down German airplanes. Known as the Red Tails because of the color of their airplanes, the Tuskegee Airmen shared in the glory.

In June 1944, the 99th Squadron joined with the 332nd Fighter Group under the command of Colonel Davis. They were assigned to the dangerous mission of escorting bombers. They shot down forty German planes without losing a single American or British bomber to the enemy. The 332nd flew fifteen thousand combat sorties and participated in the longest bomber escort mission in the entire war.

After Germany surrendered in 1945, the 332nd Fighter Group was disbanded. Staff Sergeant Andrew Smith came home. He and his wife, Eveta, had three children. Andrew opened his own shop. He operated Smith's Auto Body Shop for forty years in Coatesville. He was active in the community, serving on the Coatesville School Board. For many years he was active at St. Paul AME Church, and later in life he served in several capacities at Hutchinson Memorial AME Church. He remained an enthusiastic airplane pilot and found joy in flying as a hobby. In 1987, he was elected to the Coatesville Hall of Fame. Andrew died in 1997 at the age of seventy-six.

Several others with connections to Chester County served as Tuskegee Airmen, although little information about them has survived. William Hymes was from Lincoln University. Horace Thomas was from Coatesville. Louis Jackson was from West Chester. Dr. Bernard Proctor grew up in neighboring Delaware County but lived in West Chester for many years. He was a college professor who became vice-president of Cheyney University. (During the days of segregation, Cheyney was the state college for blacks.)

# The Twentieth Century

The Tuskegee Airmen made extraordinary contributions to the struggles to win the war, but their success also helped to change attitudes about blacks. In 1948, by executive order, President Harry Truman integrated the United States Armed Forces, calling for equality of treatment and opportunity for all military members, white or black.

*Notes: News clippings and miscellaneous data from CCHS; Tuskegee Airmen Inc.; Tuskegee Airmen National Historic Site; interview with Andrew Smith's sister, Nannie Lambert.*

## FILMING *THE BLOB* AT YELLOW SPRINGS

Historic Yellow Springs in Chester County has had a remarkable three hundred years of history, beginning with visits by the Lenape to the yellow spring waters. Long before the American Revolution, the location served as a health spa. During the Revolution, a military hospital was built to serve the Continental army. Then the village returned to use as a health resort. After the Civil War, a boarding school was established for the orphans of soldiers killed in the war. In 1916, the Pennsylvania Academy of Fine Arts created a summer campus for art students. For more than twenty-two years in the mid-twentieth century, a film production company used Yellow Springs as its studio headquarters. It was at this time that the movie *The Blob* was filmed at several locations in Chester County.

Good News Productions was founded by Irvin "Shorty" Yeaworth Jr. Shorty was the son of a minister, and he had planned to become a minister himself. While he was studying at Franklin and Marshall College, he became interested in film, radio and television, so he decided that he could better serve Christian ministry by working in those media. He became program director for a radio station at Providence, Rhode Island Bible Institute, which led to a series of radio and television assignments, most of them connected with religious programming.

Yeaworth created Good News Productions to make Christian films and religious education films for television. In 1952, the incorporated company purchased a 151-acre village with several buildings known as Yellow Springs.

The crew of Good News Productions filmed several movies while headquartered at Yellow Springs. Here in 1953, Shorty Yeaworth directs from the top of a ladder in front of the Washington Building. *Historic Yellow Springs, Chester Springs, Pennsylvania.*

Shorty enlisted help from family and friends to establish a group of dedicated religious filmmakers. They moved into buildings on the property and shared responsibilities, much like a commune. Most were paid about ten dollars per week, plus room and board. The participants were idealists, willing to work long hours for little pay. In the 1950s, as many as fifty were working and living at Yellow Springs. Hundreds of religious films were produced at Yellow Springs for use in churches and religious schools and for fundraising and evangelical outreach.

In 1955, Good News Productions' application for nonprofit status was refused. Although its many Christian films were popular with church groups, Yeaworth and the board of directors recognized that the company needed another source of income. It created a commercial film company called Valley Forge Films, which produced documentaries for clients such as the Freedoms Foundation and educational programming for television,

# The Twentieth Century

including *Secret Island*. The company also produced several science fiction movies for commercial release. The best known is *The Blob*, filmed in 1958 on location in Chester County from the original script titled "The Molten Monster." Most of the film was made in the Yellow Springs studios, but some exterior shots were necessary. The Colonial Movie Theatre in Phoenixville made for a memorable scene with actors and extras (company workers and community members) running out the front doors in panic. A climactic scene shows the Blob devouring a diner. The original wooden diner in Downingtown was replaced many years ago, but the movie theatre has been restored and holds a yearly "Blob" Festival.

*The Blob* continues to be a favorite among science fiction buffs because of its vintage special effects made long before the digital age. The Blob was made of silicone manufactured by Union Carbide and used in the production of rubber during the 1950s. It was a clear synthetic substance that withstood heat and was resistant to moisture, sunlight and harsh weather. Silicone's versatility makes it useful in oxygen masks and as coating for electrical wire and gaskets.

A principle of modest-budget filming maintains that "less is more." Oftentimes, scary scenes succeed because of what is left to the imagination. *The Blob*'s action had to be created in miniature and carefully filmed with time-lapse photography to control the speed of the Blob's movements because silicone moves very slowly. Director Shorty Yeaworth spent three weeks filming the regular scenes with the actors. A young Steve McQueen starred with Aneta Corsaut as his girlfriend. Artist Bart Sloane was responsible for creating the silicone Blob, designing the animation and building the miniature sets needed to film the Blob sequences. Sloane worked closely with Tom Spalding, the director of photography, and still photographer Vince Spangler to create the illusion of the Blob devouring everything that came in its path. Karl Karlson designed the device that made the silicone move through the miniature sets. In the age of computerized imaging, we tend to forget the talents needed to create special effects in the early movies. *The Blob* has remained popular because of the creative skills of the film company crew who lived and worked at Yellow Springs in the 1950s.

Wes Shank is a science fiction fan who began collecting souvenirs from the glory days of science fiction movies. He owns the original Blob silicone and

has written an entertaining book about the film and its makers titled *From Silicone to Silver Screen: Memoirs of the Blob (1958)*. Since 1974, Historic Yellow Springs, Inc., has preserved the historic buildings and springs of this unique village with a diverse history.

*Notes: News clippings and miscellaneous data from HYS; Shank,* From Silicone to Silver Screen.

## BAYARD RUSTIN AND THE 1963 MARCH FOR JOBS AND FREEDOM

Quaker pacifist and civil rights leader Bayard Rustin was born in West Chester in 1912. Although he lived much of his adult life in New York, he returned to Chester County often to visit family and friends and to speak at local schools. At West Chester Senior High School, he excelled in academics, sports, music and debate. Bayard was valedictorian of his class when he graduated in 1931, an extraordinary accomplishment for a young black man in a segregated community. He devoted his life to civil rights, but his actions were often controversial. Concerns about his private life sometimes kept him out of the limelight, but he worked tirelessly for the cause. He was arrested twenty-two times for civil rights protests. The first time was as a teenager refusing to sit in the "colored" section of the local movie theatre.

In 1963, civil rights, labor and religious groups planned a joint march in Washington, D.C., called the March on Washington for Jobs and Freedom. The parade would hopefully help push the government to pass the Civil Rights Act, fully integrate the public schools, pass the Fair Employment Act and set up a job training program for the unemployed. Plans for such a march were challenging. The organizers hoped to fill the mall, but they really had no idea who would show up. Bayard Rustin was recognized by his peers as a brilliant, efficient and dedicated organizer. Philip Randolph put Rustin in charge of organizing the march, because he thought that no one else could execute the plan in just eight weeks.

Rustin would serve as liaison between the other organizers and the city officials. He was asked to arrange for getting marchers into Washington,

## The Twentieth Century

West Chester native Bayard Rustin, *left*, seen here with Cleveland Robinson, organized the 1963 March on Washington for Jobs and Freedom. *Library of Congress Prints and Photographs Collection.*

feeding and caring for them during the protest and getting them safely out of the city. Rustin applied for permits from the Park Service and the police. He had to estimate the numbers and get permission for the marchers to fill the mall between the Washington Monument and the Lincoln Memorial. Rustin estimated 100,000 marchers, a huge number at the time. Officials doubted that this many would appear. He had to find parking for buses and cars. He persuaded the railroads to add trains to their schedules. Arrangements for microphones, speaker stands and amplification for musicians needed to be planned, approved by the Park Service, installed before the march, protected from vandals and dismantled promptly after the event. Food had to be purchased, stored and made available to speakers and performers. Water was made available at intervals throughout the mall. Nearly three hundred portable toilets were rented, delivered, set up, maintained and dismantled.

Several first-aid stations were established on the mall. The emphasis of the march was peaceful protest, so Rustin appointed fourteen leaders to be marshals to help keep order and keep the march nonviolent.

Not all black leaders supported the march. Malcolm X of the Nation of Islam called the march a farce. Many were concerned about the potential for violence. Many worried that if the march failed it would set back the movement, but Bayard Rustin remained optimistic. He indicated that he had a great deal of help. Officials were cooperative in approving permits and arranging for security, based on his estimate. Local chapters of the various groups involved in the planning spread the word with pamphlets, bulletins and press releases. Rustin stated that even opponents helped promote the march. Some southerners aided the cause with their cattle prods, fire hoses and recent torchings of churches, which made the American public sympathetic. Television coverage also helped by bringing the event to American living rooms.

March organizers hoped that the crowd's behavior would remain peaceful throughout the day. Guidelines were offered in the publicity for the march. It was suggested that participants dress in comfortable shoes and wear a hat and sunglasses. Participants were strongly urged to leave their children at home. Marchers were told to bring their own water and food that would not spoil. The National Council of Churches offered to supply box lunches to be sold for fifty cents.

At 6:30 a.m. on the morning of August 28, 1963, reporters began to gather at the Lincoln Memorial. With few people in sight, reporters were skeptical of the estimated 100,000 that Rustin expected. Would they come? Would they march peacefully? Were the more than 500 media representatives wasting their time? They need not have worried. Twenty-one special trains came to Washington full of marchers. Two thousand buses were met by motorcycle escorts. On-street parking was restricted in the area surrounding the mall. The District of Columbia had more than 5,000 police on hand to patrol the parade.

Marchers soon appeared. Within a few hours, more than twice Rustin's estimate gathered peacefully on the Washington Mall. It was the largest gathering of its kind. Many wore the official parade button of black-and-white hands clasped in unity. The church council provided and sold

eighty thousand box lunches. The crowd gathered peacefully to listen to speakers and musicians. Marian Anderson sang the national anthem, and others raised their voices throughout the program. Ministers, priests and rabbis offered prayers. Civil rights leaders offered their pleas for peace, jobs and equality. Best remembered was Dr. Martin Luther King Jr.'s "I Have a Dream" speech. When the program was over, participants peacefully departed and returned to their homes with a renewed hope for equality and jobs. With an estimated attendance of close to 250,000, it was the largest gathering ever in Washington, D.C. Bayard Rustin's job was not complete until all the buses and trains departed, the sound systems were dismantled, the temporary lavatories were carted away, the water and first-aid stations were removed and the trash was hauled away. Bayard Rustin had spent years as an activist, but organizing the hugely successful 1963 march may have been his greatest achievement in the civil rights movement.

*Notes: News clippings and miscellaneous data from CCHS;* Philadelphia Inquirer *from Chester County Library Database; Martin Luther King Jr. Research and Education Institute website.*

## THE JOHNSTON GANG

In the 1960s and 1970s, Chester County was plagued by a collection of thieves known as the Johnston Gang. Bruce Johnston Sr. and his brothers, David and Norman, directed a loosely knit group of criminals who operated in southern Chester County and several places in Delaware and Maryland. Although they were willing to steal anything, their specialties included money, tractors, lawnmowers, Corvettes and merchandise by the truckload. Members of the gang included brothers Ancell, Ray and Jimmy Hamm, Gary Couch, Roy Myers, Jim Dotson, Jimmy Griffin, Leslie Dale, Ricky Mitchell, Jackie Baen and Ken Howell. The gang often used local "fences" to unload the stolen goods, including Ed Otter, David "Buffalo" Schonely, Jim Mark, Franny Matherly and Benny LaCarte. In the mid-1970s, the gang expanded to include teenagers, some of them related to Bruce Sr. Known as the kiddy gang, members included Bruce's son Bruce Jr. and stepson Jimmy

Johnston. Others involved in theft and drugs were Dwayne Lincoln and brothers Wayne and Jim Sampson.

In twenty years, more than three hundred crimes were directly connected to the Johnston Gang. Bruce Sr. began in 1958 with stealing five dollars' worth of gasoline. They stole Corvettes, dismantled them in their own chop shops and resold the parts through Corvette World. Tractors and lawnmowers were stolen from private homes and dealers. Many were resold or "fenced" in Boyertown and in Maryland. Sometimes the gang stole for special requests. Bruce Sr. acquired a General Motors key machine, simplifying the reselling process by making keys for the stolen cars. Another gang specialty was overnight break-ins of markets and amusements parks, such as Dutch Wonderland and Longwood Gardens. Planning for these break-ins included members visiting the sites to locate storage areas, identify alarm systems and observe the routines of security guards.

Some of the stories about the gang are humorous. One time, newly installed red carpet was stolen from the Pennsbury Township Building. When the state police went to the nearby home of Louise Johnston (mother of Bruce, David and Norman), there was red carpet throughout the house. Mrs. Johnston claimed that someone had left it on her front porch as a gift. Over the years, the Johnston brothers had amassed stolen loot worth millions of dollars, but two of them were arrested in 1978 for shoplifting at a mall in Berks County. Stealing eight-track tapes seemed like a small item for experienced thieves, but as Norman explained, the Johnstons didn't like to pay for anything. It was just part of the business that all members might spend time in jail, but convictions were rare. The Johnston brothers were well represented by attorneys and filed every appeal opportunity, so in the early years little time was wasted in prison.

In the late 1970s, the gang unity began to fall apart, and the crimes included murders of gang members. Some gang members resented being shortchanged with their share of the Longwood Gardens burglary. Apparently, close to $50,000 was taken, but Bruce Sr. divided up only $20,000. The murders may have started in 1970 when twenty-three-year-old Jackie Baen was found floating in Brandywine Creek. He was last seen arguing with the Johnston brothers at a bar near Thorndale. In 1972, policemen Bill Davis and Dick Posey were found shot in their patrol car outside the Kennett Square police

station. Ancell Hamm was convicted, but it was thought that others were also involved. Throughout the 1970s, evidence about the gang was gathered. A team of police investigators from several agencies worked together to solve the numerous crimes, including Chester County detectives Michael Carroll, Charles Zagorski and Larry Dampman, state police troopers J.R. Campbell and Gabe Bolla, state investigators Tom Cloud and Ray Salt and Federal Bureau of Investigation agent David Richter. Staff from William Lamb's district attorney's office also helped.

The kiddy gang took orders from Bruce Sr., but members also got involved in drugs. Bruce Jr. was arrested and placed in Chester County Farm Prison. During his incarceration, his fifteen-year-old girlfriend, Robin Miller, reported that she had been raped by his father and another member of the gang. Bruce Jr. was very angry and agreed to cooperate with the police if he could be freed. His father learned of his intent and ordered that Bruce Jr. be killed. On August 30, 1978, when Bruce and Robin returned to her home, Bruce Jr. was shot eight times. Miraculously, he did not die from the wounds. One of the bullets went through him and into Robin's face. She died a few minutes later. The police later learned that Robin was not the first teenager killed that year. Several members of the kiddy gang had disappeared. While Bruce Jr. was in jail, the Johnston brothers decided that some of the other young men were in danger of talking to police about the crimes, so they killed Jimmy Sampson, Wayne Sampson and Jimmy Johnston, stepson of Bruce Sr.

Police officers worked long hours and shared information with each of the divisions. They arrested some of the gang members and made deals to get them to talk. In 1979, all three Johnston brothers were indicted for murder. The trials were prosecuted by Assistant District Attorney Delores Troiani and District Attorney William Lamb. Due to the publicity, the trial of David and Norman was held in Ebensburg in Cambria County. In January 1980, the two younger brothers were charged with the murders of the Sampson brothers, Jimmy Johnston and Wayne Lincoln. They were convicted on March 18, 1980. Before the trial of Bruce Johnston Sr. began, the state revised the rules for change of venue. His trial would take place in Chester County, with the jury coming in from Erie.

The trial began on October 6, 1980, and ended on November 15. Bruce Sr. was convicted of five murders in the first degree—the same four young

Members of the Johnston Gang were tried at the Chester County Courthouse in West Chester, Pennsylvania. *Photograph by Susannah Brody.*

men plus Robin Miller. Due to the lengthy appeal process, David Johnston was sentenced in 1983 to four consecutive life sentences. (Pennsylvania had no death penalty then.) Norman was given the same sentence, but in 1999 Norman escaped from Huntington Prison and spent three weeks roaming around southern Chester County and northern Maryland before being recaptured. Several years were added to his life term for that escape. In 1986, Bruce Sr. was sentenced to five life terms. Bruce Johnston Sr. died in

prison of liver failure in 2002. Presiding Judge Leonard Sugarman praised the extraordinary cooperative efforts of the various law enforcement agencies that brought the Johnstons to justice. In the years after these notorious trials, many others involved with the Johnston Gang were also tried and convicted, finally bringing to an end the crime sprees of Chester County's most famous criminals.

*Notes: Mowday,* Jailing the Johnston Gang; Philadelphia Inquirer *from Chester County Library Database; news clippings and miscellaneous data from CCHS.*

## THE KU KLUX KLAN PARADE

In December 1990, the Ku Klux Klan made plans to march in West Chester, Pennsylvania. Rick Fogel, the grand dragon of Pennsylvania's klaverns (groups), arranged for the parade as a protest against the day commemorating Martin Luther King Jr. The designation of the third Monday in January was passed in 1983 and enacted in 1986, although the day was not celebrated in all fifty states until 2000.

The Ku Klux Klan is a secret society, so no one knew about the klavern in West Chester until Fogel contacted the borough to obtain a permit to march. The permit was granted for Saturday, January 12, 1991, despite opposition from many in the community. The borough council granted permission based on the first amendment of the United States Constitution, ensuring freedom of speech. The Klan march became a "teaching moment" in area public schools. Lawyers, judges and borough officials, including Mayor Tom Chambers, visited schools to talk about freedom of speech, as well as the philosophy of the Ku Klux Klan as a white supremacist organization.

Many in the community were upset about the planned march and the realization that there was a Klan group in West Chester. Less than two weeks before the parade, community leaders planned "Unity Day," an alternative celebration at West Chester University. Organizers included Mayor Chambers, West Chester NAACP president Reverend Ed Williams, Hosanna AUMP Church reverend Charles Lawson and community leader W.M.T. Johnson. The idea was to offer an alternative to watching the

parade. Meanwhile, the police department was also making plans. The entire West Chester police force was called to duty, assisted by several state police. Representatives from most of the police departments in the county volunteered to assist. Realizing that outsiders were likely to come to West Chester, Bob Galen, police community relations officer, was put in charge of coordinating the event. The parade would loop around two square blocks in the center of town. Traffic would be detoured, parking was restricted, stores were closed and regulations regarding spectators were formulated. No vehicles would be permitted to park on the streets or in the borough parking lots at West Market and South High Streets. Stores on two blocks of Market and Gay Streets were closed, and some owners boarded up their windows. Dogs were not permitted in the area, and observers could not carry signs or flags on sticks. The police had been told to expect two hundred KKK members, and they were aware that outside groups often attended these events. Of particular concern was INCAR, the International Committee Against Racism, which had a history of violence against the Klan.

On the morning of Saturday, January 12, Klan members met in Exton and carpooled to West Chester with a police escort. Thirty-two hooded Klansmen (some from New Jersey and Maryland) and fifteen white supremacist skinheads were surrounded by uniformed state police, including ten mounted troopers. Starting at the corner of Darlington and Market Streets, they marched two blocks on Market Street, turned onto High Street in front of the courthouse and then marched two blocks on Gay Street and one block on Darlington before coming back to the starting point. The marchers carried signs that said "White Power," "Join the KKK" and "Fight for the White."

More than two thousand spectators lined the sidewalks and were peaceful at first, some shouting at the Klan but without exerting any violence. After the parade turned at the courthouse, vocal outbursts increased. The Klan and their friends smiled and waved. Several snowballs were thrown and then a few bricks, but no one in the parade was injured. The police arrested seven at the parade. Most of them had tried to attack Klan members after the march, when they were returning to their cars in a fenced-in parking lot. The police were able to keep the two groups apart, and the Klan left West Chester after a parade that lasted just twelve minutes. By the end of the

# The Twentieth Century

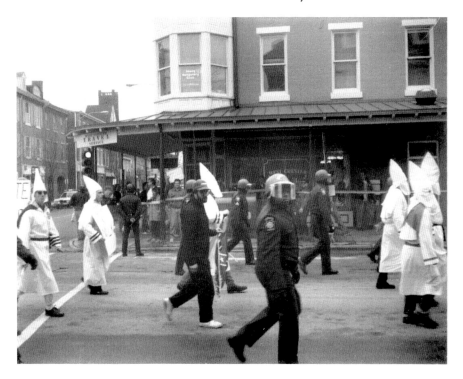

Ku Klux Klan marchers were escorted by West Chester police. *Photograph by Sarah Wesley, Chester County Historical Society, West Chester, Pennsylvania.*

march, many were angry with the police, who were responsible for keeping the Klan marchers safe. The spectators continued to shout obscenities and initiated a spontaneous anti-Klan march east on Market Street.

People were unhappy that the police protected the Klan but arrested protesters. About three hundred people marched to Borough Hall and stood outside yelling for police to release those arrested. Someone threw a brick at the chief of police but missed him and hit a state police officer from Lancaster. Rain began to fall, and the state police were called back for support. By mid-afternoon, Chief Green spoke to the crowd and then retreated into Borough Hall. The wet crowd finally dispersed. Thirteen were arrested, seven at the parade and six at Borough Hall. Of those arrested, three were from West Chester. The rest were from Philadelphia or had unknown addresses.

Meanwhile, the Unity Day at West Chester University attracted 1,600 participants, most of them from West Chester, for a two-and-a-half-hour

program. The rally began at 12:30 p.m. Speakers included Mayor Chambers, Reverend Williams, Reverend Lawson and several local residents, who all praised West Chester and the brotherhood of unity that had been created. Invocations were given by Reverend LaVerne Harris of Bethel Church, Monsignor Thomas Craven of St. Agnes Church and Burton Neil, president of Kesher Israel Congregation. Several students read essays they had written. The speeches were interspersed with entertainment from a local band, the Voice of Reason, Amerikids, entertainers Annie and Walt and dancers from the Diane Matthews Studio. Many remember with distaste the twelve-minute march of the thirty-two Klan members and fifteen white supremacists, but the Unity Day celebration inspired similar gatherings on Martin Luther King Day for several years and led to the Martin Luther King Day of Community Service.

*Notes: News clippings and miscellaneous data from CCHS,* Philadelphia Inquirer *and* Daily Local News *from Chester County Library Database; interviews with Sarah Wesley and Alice Hammond.*

## Return to Duffy's Cut

Duffy's Cut is a section of the railroad between Malvern and Frazer where in 1832 fifty-seven Irish immigrants died of cholera while constructing the railroad through a ravine. Since that tragedy, the story of Duffy's Cut has moved into the realm of local lore and legend. Documented facts about the story were lost over time, but undocumented tales of ghosts and murderers survived. Although there are many nonbelievers, this is a story filled with ghosts and coincidences. Dr. William Watson is a professor of history at Immaculata University, located about a mile from the site of Duffy's Cut. In September 2000, Dr. Watson and his friend, Tom Conner, saw an apparition on the college campus. They thought the three glowing forms seen briefly on the lawn were perhaps a student art project. That same year, a townhome community was built near Sugartown Road and King Road, closer to the location of the railroad. Several new residents reported seeing similarly strange sights.

# The Twentieth Century

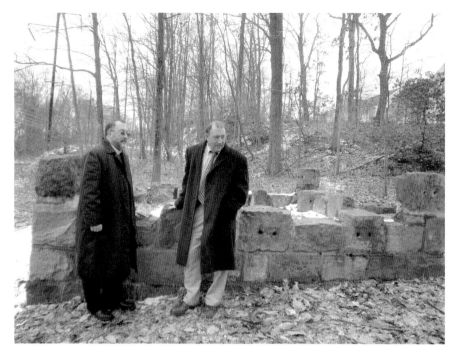

Dr. Frank Watson, *left*, and Dr. William Watson stand near the stone enclosure honoring the fifty-seven Irish laborers who died of cholera while constructing the Philadelphia and Columbia Railroad in 1832. *Photograph by Susannah Brody.*

Some called the visions ghosts, while others refused to believe that ghosts existed, but they could not explain the visual phenomena.

In August 2002, Dr. Frank Watson shared with his brother a file that he had found years before among their grandfather's belongings. Their grandfather, Joseph Tripican, had been administrative assistant to Pennsylvania Railroad Company president Martin Clement. When the railroad company went into bankruptcy in 1970, Tripican was permitted to remove items from the vault. Among the items that Tripican saved from destruction was a file of information that Clement had gathered in 1909 when he was assistant superintendent of the Paoli rail yard. The file told the 1832 story of Duffy's Cut.

Although he had not heard of Duffy's Cut before this family gathering, Bill Watson was impressed with the coincidences: he worked near the site; the man who compiled the information once worked at Paoli; his grandfather worked for the man who created the file; and others had seen strange sights

similar to what he and his friend had seen. He learned that for many years after the cholera outbreak local residents would tell stories of ghosts being seen near Duffy's Cut. Some were nothing more than an aura, but one of the ghost stories described three glowing forms dancing near the mass grave. The description was similar to the images seen in 2000.

The brothers were both interested in research, so with their grandfather's file as a resource they began a journey to discover more about Duffy's Cut. The information gathered inspired others to join them, and so the Duffy's Cut Project was formed. Adjunct professors John Ahtes and Earl Schandelmeier of Immaculata's history department, Dr. Tim Bechtel of the University of Pennsylvania and some student interns were all curious to see what they might find at the site of the Irish immigrants' encampment. Eventually, the project accessed the talents of archaeologists, a geophysicist, a physical anthropologist, a biologist, a forensic dentist and the county coroner. Research trips were organized to study the railroad, Irish immigrants, contractor Philip Duffy, East Whiteland Township and the nuns who came to help. They hoped to commemorate the site with a Pennsylvania State Historical Marker, but they quickly learned that the competition for the markers was stiff and the application process difficult. The application was submitted in the fall of 2003.

Project members spoke to many organizations interested in Irish heritage and local history. Professors Watson and Ahtes are members of an Irish-American organization, the Ancient Order of Hibernia. They provided informational programs to gain publicity and appeal for financial support. Several newspapers devoted space to the story. An Irish-American organization whose members work in law enforcement, the Chester County Emerald Society, joined in the effort. In 2003, Immaculata University's history department, the Emerald Society and the Chester County Parks and Recreation Department formed a research collaboration to properly commemorate the men of Duffy's Cut. Support from local politicians was also enlisted. In addition to the research, the men hoped to locate the remains and have them reburied at consecrated grounds. Walter Mehl, supervisor of West Laurel Hill Cemetery, offered burial space in the cemetery in Bala Cynwyd.

Spring 2004 was an eventful time; the project received permission from the residents' association that now owned much of the ravine known as

# The Twentieth Century

Duffy's Cut to hunt for the men. The research team combed the site along the railroad and discovered many artifacts. First, they hunted for the stone wall that Clement had built around the grave site near the train tracks. After locating the wall, they hunted through the adjacent valley. They found Irish tobacco pipes, belt buckles and cooking utensils. They even found some bones, but not human ones. (In another odd angle to the story, the ravine south of the railroad once had the nickname "Dead Horse Hollow"; according to local legend, the carcasses of dead horses were dumped there in the nineteenth century, inspiring their own ghost stories. The team found horse bones, validating the legend.)

In March, the Pennsylvania Historical and Museum Commission approved the marker. The Emerald Society provided the funding, and on June 18, 2004, the historical marker was dedicated and installed at the intersection of Sugartown and King Roads. Once word about the project spread through the community, Dr. Watson was contacted by people who shared more ghostly experiences. One man related that when his family lived in the area in the 1970s, his sister collected things in the woods nearby and saw visions of someone looking in her window. When she got rid of the artifacts, the visions also went away. In September 2004, a Malvern resident saw the glowing figures near the sign just after she had turned from King Road onto Sugartown Road.

The publicity on Duffy's Cut reached several newspapers in Ireland and spurred the interest of an Irish film company, which came to Malvern to film the site. Tile Films of Dublin created a film, *The Ghosts of Duffy's Cut*, that was nominated for documentary awards in 2007 and was purchased by the Smithsonian Institution. In 2006, the Watson brothers, John Ahtes and Earl Schandelmeier published a book, *The Ghosts of Duffy's Cut*, that summarized the extensive research and is used as the textbook for a course offered at Immaculata University. In March 2005, the Immaculata Library installed an exhibit showing many of the artifacts. More ghostly incidents were reported at the library while the exhibit was in place.

The project members continued to search and research whenever time permitted. At least a dozen digs were executed during 2004 and 2005, although lack of funding sometimes delayed the work. Several metal detectors were acquired that helped to locate many railroad artifacts. Finally,

ground-penetrating radar was used to locate possible graves since the stone-walled memorial was unlikely to be the real mass grave site. Certain locations within the fill of the railroad embankment were identified as likely sites for the graves.

In March 2009, the team discovered graves with human remains! The bones of four men have been identified in individual graves. These were most likely the first of the men to die from cholera. The bones were carefully removed to the University of Pennsylvania Museum for examination and preservation. Careful study of a skull revealed that one of the men died from a severe blow to the head. The county coroner declared the site a crime scene. Could the early lore be true? Did vigilantes kill the Irish immigrants because they brought the cholera to the county? The mystery continues.

*Notes: Watson, Watson, Ahtes and Schandelmeier,* The Ghosts of Duffy's Cut; Immaculata *magazine, "Duffy's Cut Discovery," 7;* Philadelphia Inquirer *and* Daily Local News *from Chester County Library Database; news clippings and miscellaneous data from CCHS; interview with Dr. William Watson of the Duffy's Cut Project, www.duffyscutproject.com.*

# Bibliography

Adams, Charles J. *Ghost Stories of Chester County and the Brandywine Valley.* Reading, PA: Exeter House Books, 2001.

Brody, Susannah. "Ann Preston, M.D. Pioneer in Medical Education and Woman's Rights." Thesis, Degree of Master of Arts in Oral Traditions, Graduate Institute, Milford, Connecticut, 2004.

———. *Constant Struggles: The Nineteenth Century.* West Chester, PA: Chester County Historical Society, 2000.

———. *An Honest Heritage: The Twentieth Century.* West Chester, PA: Chester County Historical Society 2001.

———. *Prosperous Beginnings: A Quaker Colony.* West Chester, PA: Chester County Historical Society, 1999.

Cavanah, Frances. *Jenny Lind's America.* Philadelphia, PA: Chilton Book Company, 1969.

Chadds Ford Historical Society. Miscellaneous information on Elizabeth Chads. Chadds Ford, Pennsylvania.

Chester County Historical Society Library. Manuscript collection, news clippings collection, church records, genealogical records, Pennsylvania colonial records and miscellaneous information. West Chester, Pennsylvania.

# Bibliography

Chester County Library System, Exton, Pennsylvania. Database for the *Daily Local News* and the *Philadelphia Inquirer*.

Cryer, Richard. *Longenecker Family Newsletter* 1, no. 1 (January–February 1999).

Darlington, Richard, Jr. *Full Description of the Great Tornado in Chester County.* West Chester, PA: F.S. Hickman, Printer and Publisher, 1877.

Downey, Dennis B., and Raymond M. Hyser. *No Crooked Death: Coatesville, Pennsylvania and the Lynching of Zachariah Walker.* Chicago: University of Illinois Press, 1991.

The Duffy's Cut Project. http://duffyscut.immaculata.edu.

East Whiteland Township Historical Commission. *The Battle of the Clouds.* Pamphlet. Frazer, PA: East Whiteland Township Historical Commission, 1975.

Francis, Charles E. *The Men Who Changed a Nation: The Tuskegee Airmen.* Boston, MA: Brandon Publishing Company, 1988.

Futhey, J. Smith. *The Massacre of Paoli. Historical Address Delivered on the Centennial Anniversary of That Event at the Dedication of the Monument to Those Who Fell on the Night of September 20th 1777.* West Chester, PA: F.S. Hickman, Printer, 1877.

Futhey, J. Smith, and Gilbert Cope. *History of Chester County, Pennsylvania.* Philadelphia, PA: Louis H. Everts, 1881.

George, Linda, and Charles George. *The Tuskegee Airmen.* New York: Grolier Publishing, 2001.

Happersett, Constance, Patricia Gaines and Susannah Brody. *Dear Sister: A Collection of Civil War Letters Written by Joseph and William Downing to Their Sister Sarah of Lionville, Pennsylvania.* Exton, PA: Uwchlan Township Historical Commission, 2004.

Historical Society of Phoenixville. Miscellaneous information on the Pickering Valley Railroad. Phoenixville, Pennsylvania.

Historic Yellow Springs Archives. Miscellaneous information. Chester Springs, Pennsylvania.

*Immaculata* magazine. "Duffy's Cut Discovery." Edited by Carola Cifaldi (Fall 2009).

Lewis, Noah. "Ned Hector." www.nedhector.com.

Lukens, Rob, and Sandra S. Momyer. *Images of America: Yellow Springs.* Charleston, SC: Arcadia Publishing, 2007.

# Bibliography

MacMaster, Richard K., Samuel Horst and Robert Ulle. *Conscience in Crisis*. Scottdale, PA: Herald Press, 1979.

Martin Luther King Jr. Research and Education Institute. http://mlk-kpp01.stanford.edu/index.php/encyclopedia/encyclopediaenc_march_on_washington_for_jobs_and_freedom.

McGuire, Thomas J. *Battle of Paoli*. Mechanicsburg, PA: Stackpole Books, 2000.

Minutes of the Supreme Executive Council of Pennsylvania, Vol. 13. Colonial Records. Philadelphia, PA: Jo. Stevens & Co., 1853.

Mowday, Bruce E. *Jailing the Johnston Gang: Bringing Serial Murderers to Justice*. Fort Lee, NJ: Barricade Books, 2009.

National American Woman Suffrage Association Collection, 1848–1921. http://memory.loc.gov/ammem/naw/nawshome.html.

Pleasants, Henry. "Battle of the Clouds at Frazer May Have Been Turn of the Tide in Great American Revolution." *Picket Post*. Valley Forge Historical Society, April 1946.

Roark, Carol Shields. "Historic Yellow Springs: The Restoration of an American Springs." *Pennsylvania Folklife* 24, no. 1 (Autumn 1974).

Rodebaugh, Paul A. *Chester County Notebook*. West Chester, PA: Taggart Printing Corporation, 1987.

———. *More Chester County Notebook*. West Chester, PA: Taggart Printing Corporation, 1990.

Shank, Wes. *From Silicone to Silver Screen: Memoirs of the Blob (1958)*. Bryn Mawr, PA, 2009.

Slaymaker, Samuel R. "Mrs. Frazer's Philadelphia Campaign." *Journal of the Lancaster County Historical Society* (1971).

Smedley, Dr. Robert C. *History of the Underground Railroad in Chester and Neighboring Counties of Pennsylvania*. Lancaster, PA: Lancaster County Historical Society, 1883.

Snyder, Michael. "The Battle Axes of Free Love Valley." *Pottstown Mercury*, January 4, 2009.

*Sunday Bulletin*. "Neighbors Freed Old Woman in 1780 West Chester Witch Trial." October 31, 1965.

Temple, Anna B. *Anna B. Temple: Her Diaries*. Transcribed by Estelle Cremers. Research compiled by Susannah Brody and Constance

# Bibliography

Happersett. Exton, PA: Uwchlan Township Historical Commission, 1990.

Temple, John. *History of Lionville and Vicinity.* Lionville, PA: privately printed, 1927.

Tuskegee Airmen Inc. http://www.tuskegeeairmen.org.

Tuskegee Airmen National Historic Site. http://www.nps.gov/tuai/index.htm.

Watson, Dr. William E., Dr. J. Francis Watson, John H. Ahtes III and Earl H. Schandelmeier III. *The Ghosts of Duffy's Cut: The Irish Who Died Building America's Most Dangerous Stretch of Railroad.* Westport, CT: Praeger Publisher, 2006.

Wright, Jules Noel. "Free Love and the Battleaxes." *Picket Post*, 1982.

Zigler, William. "Community on Trial: The Coatesville Lynching of 1911." *Pennsylvania Magazine of History and Biography* 106 (April 1982).

# About the Author

Chester County resident Susannah Brody is an author and storyteller with an interest in local history. She has a master of arts degree in oral traditions from the Graduate Institute in Connecticut. She is a member of Patchwork: A Storytelling Guild and the National Storytelling Network. She has written several books on local history. Susannah served on the Uwchlan Township Historical Commission for thirty years. She volunteers at the Chester County Historical Society and Hopewell Furnace National Historic Site. Her storytelling activities include programs for all ages, living history portrayals and workshops on storytelling and developing living history characters.

*Photograph by Ronald Brody.*

Visit us at
www.historypress.net